EDMOND TRAN

THE LAST OF THE DALMATIANS

Translated from French by Barbara Silverstone

Edmond TRAN, 23 rue des saints pères 75006 Paris France
Phone number : 00 33 6 21 68 85 17

edmond.tran@hotmail.fr

CopyrightDepot.com N°00050473

For my two loves: My wife Marianne and my Dalmatian Balkan.

1/ Beverly Hills, California.

Her bedroom had just been invaded by hordes of stupid barking dogs. Just before the film credits, the number of Dalmatians in the final scene seemed incalculable, reminding her that she was far from accomplishing what she called "her masterpiece." Yet, there were "only" 101 of them in this version taken from the animated film by Walt Disney, itself adapted from the novel by Dodie Smith.

Jenny Palace squealed with exasperation. With over 400 channels to choose from, she had ended up with this ridiculous film. She jumped up from her heart-shaped bed and raced to her pink, sequin-covered mobile phone. Without deigning to wait for a voice to greet her, she demanded to speak with Tony Pinofarino, the car designer who was a hot commodity in recent years on the West Coast, famous for his very unique customizations that appealed to a certain type of clientele. Amongst his latest creations, which triggered the wrath of animal rights leagues, Tony Pinofarino had covered the entire exterior and interior of famous rapper Big Fat Big I's Hummer with Amazonian anaconda and snakeskin. He then repeated his crime by decorating the car body and passenger compartment of an almost 33-foot-long limo with crocodile skin for Armando Noriego, a notorious dealer who dabbled in all sorts of crime.

On the other end of the line, the secretary announced that Tony Pinofarino was unavailable. What a shame for her eardrums…

"What do you mean unavailable?!!" the capricious young diva yelled. "Tell that Italian Mafioso idiot that he has to be available AT ALL TIMES when Jenny Palace needs him. And remind him that I'm the reason he became famous!"

It's true that when the young girl billionaire was 16, she had him customize her first car, a Mercedes convertible. He covered it completely with blond hair, from the front of the hood to the back of the car, ending with a three-and-a-half-foot-long ponytail. The car had made the cover of many celebrity magazines. Then, a rumor came out on the Internet that the sleazy designer had collected hair from impoverished young women all over the world in order to fill the order for his client, who was as demanding as she was wealthy, turning a nice little profit of several million dollars with other people's golden locks. But Jenny couldn't care less about media rumors. In fact, she took a certain pleasure in creating them. At any rate, the car only survived for a matter of months before crashing into a palm tree in Beverly Hills after an out-of-control pajama party at a girlfriend's house. Better yet, the wreck was auctioned on E-bay to a Japanese curiosity collector, earning the already billionaire young woman more than it had cost her.

Beyond the shadow of a doubt, despite the considerable amounts of money that Jenny Palace managed to squander each day shopping in luxury boutiques worldwide, this big spender also had a head for business. Most people would be satisfied being a billionaire's daughter, but this wasn't enough for her. Jenny Palace had transformed her entire identity into a brand. In addition to a cosmetics range, several fragrances and a handbag line in her name, the businesswoman had just launched a clothing collection, simply called *Jenny Girl*. It was a smash hit, not only in the United States, but also in China, Japan (where the doll in her image rivaled the unbeatable Barbie) and Europe.

She had also made appearances in films, various videos and even on the music scene with her single "I am rich and beautiful" from the album *Oh yes it's good to be a queen (Oh la la...)*, which stole the No. 1 slot on the worldwide charts for six months. Her video, which showed her swimming in a pool filled with dollars, like Uncle Scrooge, before taking a shower made of gold dust, beat all the downloading records on Internet. The young heiress was living proof of the saying: "money begets money." While King Midas transformed everything he touched into gold, this party queen - who knew all the international dance floors and who had turned shopping into a lifestyle - transformed every venture into wads of green bills.

"Okay, Miss Jenny, I'll tell…" the assistant barely had the time to utter.

Then came the scream. High-pitched. Screeching. Overpowering. One of the famous trademarks of her horrible character as a brat who had been ultra-spoiled since birth. But shrieking in her 650 square foot bedroom so that all nine servants in her immense house could hear her after she exploded the eardrums of the secretary on the phone still wasn't enough to calm her down. She nervously threw her phone at poor Gucci, the fearful four-year-old Chihuahua and personal "punching bag" of the bona fide celebrity princess. As used to the fury of his mistress as he was to paparazzi camera flashes, Gucci took refuge in his weekly dog bed, a candy pink basket matching his coat of the day. Ridiculously chic.

"That's right, go hide, you disgusting rat disguised as a dog!" spat Jenny, taking off her sleep mask that she was wearing as a hair band. It was the same pink as the dog basket.

"These (…)* Dalmatians ruined my morning. But the good thing is that when this pretentious descendent of Al Capone finally gets to work, I'll be driving the most original, the most beautiful and the softest car in the entire world. Cruella De Vil is nothing but a wannabe and a has-been with her cravings for puppy-skin coats! As for me, I always get what I want. And my Bentloyce entirely covered in Dalmatian skin will make headlines all over the world. All I have to do is calm down with a little shopping…" thought the blonde heiress of the Palace family, owner of one of the most prestigious international hotel chains, amongst other things.

After almost 26 years of doing exactly what she pleased, the too-famous Jenny Palace was nicknamed by the world press as *"the poor dirty rich girl."*

*In order not to offend our readers, we were not able to print certain words of Jenny Palace's refined vocabulary.

2/ Malibu Beach, California. Eddy and Bogart's apartment.

Eddy Fellow had been glued to his laptop for at least an hour. In other words, in dog language, it had been light years since Eddy hadn't played with his four-footed friend. Without looking away from his beloved master or moving a paw, Bogart blew air through his chops to attract some attention.

"Pff…" once. "Pff…" twice. Bogart was a young 26-month-old Dalmatian. When he sighed like this, his cheeks seemed to puff out like a pair of bellows. As if saying, "I'm bored, old friend. It's about time you paid attention to your favorite pet."

Yet, Eddy continued to pound madly away on his keyboard. Humans really had strange habits. Why shut himself up for hours in front of a stupid screen when they could be surfing the waves of Malibu or Huntington Beach together, playing fetch or skating on Santa Monica – or when he could be simply walking on the beach with his faithful companion? Man's eternal best friend. Batman's Robin. Jerry's Ben. Shaggy's Scooby. In short, his canine friend. And these humans were also kind of deaf sometimes. It's true that their ears were very small. And strange-looking. Like so many things on their bodies. Nothing like the ears of Dalmatians, which were so soft and sleek and spotted. So black and white. And nothing like the ears of his beach pals, either, even though theirs were different too.

Bogart thought about the pointy ears of Bingo, the Frisbee-playing Doberman who could jump 13 feet in the air, and those of Hang Ten, the Great Dane who surfed old Hawaiian style. He also thought fondly of Vanity's drooping ears, which actually looked a little like his own. Vanity was the hot little red-haired cocker spaniel

who ran along Venice Beach next to her rollerblading mistress, the young actress whom Eddy and he had recognized in a hit TV show.

Apparently, his message hadn't gotten through yet. So Bogart decided to move onto Plan B. Tired of waiting around hopelessly for his roommate to finally notice him, the bold Dalmatian decided to leave the sunny little apartment terrace that overlooked the beach. His sunbath was over. Now it was time for some sports. And some fun! The young dog, just over two years old, slowly stretched his wiry, muscle-bound body. Then he yawned noisily with his mouth wide open, but this still didn't distract Eddy. With a gliding but far from catlike movement, the Dalmatian walked through the living room, making his claws click on the wooden floor. Click, click, click. A discreet sound. Unfortunately, it was a bit too discreet, compared to the clicking keys of the keyboard. The unbearable lightness of being a Dalmatian.

Bogart reached his master and prepared for the next phase. His seduction number. A performance that he had known by heart since he was a little puppy. Used so many times but still as effective as ever. Tested on all human beings, from age seven to seventy-seven. Irresistible. Especially with women. How many times had Bogart helped his master meet young women who were smitten with the dog's little tricks? No offense to Eddy, but the women drooled over the dog before even looking at his master. Later, it was normal for them to ask how their "favorite dog" was doing before they inquired about his owner. So classic. How many dates did Bogart set up for Eddy? One thing was sure: Eddy owed him big time.

Lost in thought, Bogart imagined himself directing a canine matrimonial agency for humans. Sitting alongside his master behind a big desk with a framed photo of Eddy and himself: partners for life. Behind them, he could see many photos of happy couples who were brought together by the Bogart & Eddy agency, posing with their benefactors. "Let Bogart fetch your soul mate. Bogart & Eddy, the *top dog* dating agency."

All the same, Bogart was worried about his venerated master's love life. He had stepped up his game to help his master meet more women at the beach, in bookshops or in the DVD shops of L.A., but his master still hadn't found a woman who stood out from the pack. He hadn't found "the one." Yet, Bogart knew exactly what his master

liked. No detail ever escaped the sharp eyes of man's best friend. Clearly, Eddy had a thing for blondes with big blue eyes. And there wasn't exactly a shortage of them in California. Still, the many chance encounters orchestrated by Bogart's master paw never turned out to be long-term. Eddy seemed to be searching for someone special. Someone who, like them, would love playing ball on the beach for hours, before going surfing, savoring spaghetti carbonara (their favorite dish, especially with grated parmesan cheese), watching Scooby Doo DVD's over and over, listening to tracks by Snoop Doggy Dog on repeat in their slightly beat-up old convertible Porsche or watching the sun set over the ocean together. All perfectly reasonable criteria when you thought about it. Bogart couldn't blame his master for being so picky.

Sitting graciously on his haunches, with his tail beating energetically against the hardwood floor from left to right, as regular as a metronome, Bogart now looked at his two-legged accomplice sitting a few inches from him. His inseparable human pal was quite the looker. Objectively speaking, and not just because he was his master. Rather slim and toned, as elegant in casual wear to go to the beach as in a rented tuxedo for premieres where he took Max, his supposed agent who was supposed to introduce him to Hollywood celebrities who would one day buy his screenplays. In short, if Eddy had been a dog, he could have been a Dalmatian. This only confirmed the saying "like dog, like master." He was classic, yet sporty. Chic, yet fun. The only things missing were the spots and the silky hair.

But for now he was simply boring, hypnotized in front of his computer like a nerd in front of his Playstation. Bogart slowly moved his head to one side and then the other. Finally, he decided to speak his mind. A sound that the human brain, unfortunately just as limited in the 21st century, tends to take for moaning or crying, broke the silence of the room.

"What is it, buddy?" asked Eddy, without even looking away from the stupid screen. "Need to take a leak?"

"No, my dear (but too human) master. I just want you to spend some time with me. I want us to go run on the beach so that I can stretch out my paws and work out all my puppy energy. Although, of course, I'd never refuse to pee. After all, dogs are just walking bladders."

As usual, Eddy didn't quite understand what he was trying to say. So Bogart tried to explain with gestures, as one might do with a newborn puppy. Canine pedagogy for humans. Not an easy job. After centuries of loving understanding between the two races, humans still understood nothing about the language of dogs, whereas under the rule of the Pharaohs, Egyptian dogs already knew how to decipher hieroglyphs. Continuing his explanations, Bogart placed his paw lightly on his master's thigh, while staring at him with moist eyes. This time, Eddy finally turned away from his keyboard.

"You're right, Boogie. I haven't paid much attention to you today," he said in a soft voice, looking at the dog fondly. When his master looked at him in this way, Bogart caved in completely. It was times like this that the Dalmatian was sure that man was truly dog's best friend. Eddy continued his little number, petting his head, then his neck, first behind the ears and then under his chin. Bogart loved being petted like this. He was in Dalmatian paradise. Say what you like, but men had a knack for certain things. They just couldn't speak dog. Eddy deserved a good lick. Bogart carefully licked his master's hand, while it continued to pat the Dalmatian's soft fur.

After a few minutes of tenderness and understanding that only the two friends, with their six legs between them, could have described, Bogart took things into his own paws. He went to get Eddy's swim trunks, a pair of shorts, a shirt and a pair of Van's, a clear message that it was high time to go surfing. Then he brought his camouflage leash (the leash for the beach). So that his master would have the impression that he was walking the dog and not the other way around.

3/ Los Angeles. LAX International Airport.

Finally! She had arrived. After an almost 11-hour flight. And she wasn't even bothered by the rather long formalities to enter the territory. Marianne was so happy to set foot on American soil that she had to hold herself back from kissing the immigration officer when, after asking her the usual questions, collecting her digital fingerprints and making sure that her clear blue eyes were really her own, he had energetically stamped her French passport. Going by the enamored gaze that the officer swept over her before deigning to let her pass, he wouldn't have minded keeping her there a little longer.
Marianne had landed in the United States, country of the famous Star-Spangled Banner, superb cars, gigantic landscapes, Marilyn Monroe and Sharon Stone. The continent of pioneers, where everything was possible. Including the American dream. And in California, to boot! The State where the governor was a former actor and where the sun shined almost twelve months out of the year, giving its inhabitants a glowing complexion and its oranges a delicious flavor.
Most of all, she was starting her first stay in America in "the" city. L.A., as it was called in this country. L.A. LAX. Los Angeles. The City of Angels. And, more than that, the city where movies came to life. This had been her passion since she was a little girl. Los Angeles, with its stars of the past and present. Its famous boulevard marked with their names and handprints. Brad Pitt and George Clooney for the most seductive male actors. Vince Vaughn and Ben Stiller for the funniest. Angelina Jolie, Eva Mendez and Scarlett Johannson, big-screen beauties who would always incarnate

Hollywood glamour. She had seen almost all of their films, often several times.

L.A., the city of movie studios. Universal Studios, Warner, Disneyland. Walt Disney, her hero. The absolute master of animated films. Mickey and Donald's daddy and the benefactor of thousands of children on the planet for generations. Marianne Bonange had just graduated from FEMIS, a French university specialized in film studies. She had written her thesis on Walt Disney, with whom she shared a passion for cartoons and Dalmatians.

In fact, after picking up her luggage, she was now waiting for Barbarella, her own beautiful Dalmatian and roommate for the last 19 months whom she had chosen at a kennel club in Brittany. Because, even though she was fulfilling her lifelong dream, she just couldn't bear to leave her dog in France. More than a pet, Barbarella was her friend, accomplice and confidante. You had to actually live with a Dal to understand the tight-knit relationship that existed between the dog and its master, she liked to tell her friends.

4/ Los Angeles, California. LAX Airport.

Her beautiful, adoring mistress hadn't lied to her. If the Californian climate was like this every day, then it was well worth the journey. They had left the March rain in Paris and, from what Barbarella could see from her cage, the LAX Airport was flooded with sunshine. It almost made her forget the 11 hours that she had just spent in the luggage hold of the plane. Not that she was complaining. Dogs had it much easier than humans. What homo sapiens could stand being kept on a leash, fed dehydrated dog food and taking walks only when his master decided to? Barbarella remembered one of the many films that she had seen, one Sunday afternoon, cuddled up next to her mistress on the sofa. It was about a planet controlled by apes who transformed men into domesticated humans. This was the daily existence of dogs for generations, but just science fiction for men for the duration of a film! Good old humans... You can't live with them and you can't live without them. They're a dog's best friend. But so much more complicated.

As far back as a Dalmatian could remember, no human had ever traveled in the luggage hold of a plane inside a plastic cage with only a bowl of water. But Barbarella was not complaining. She had made the journey with two other four-footed passengers. The human airport staff had been intelligent enough to place the three cages in such a way so that they could talk together. So the Dalmatian had been able to meet two friendly travelers.

The first was Charlie, a Bearded Collie from San Francisco. After spending three years in Paris with his master, Peter Hack, a computer genius according to the sheepdog, he was returning to

California to live in L.A. His master had decided to launch a "dog dating" website: www.dogsmeetdogs.com. A site that the beardie said "was woofin' awesome." Charlie was the archetypal Californian dog. He had the furry debonair side of Benji and the cool attitude of Scooby Doo. The red bandana that he wore around his neck added a hippie chic touch like the dogs that she had seen pulling their masters on rollerblades in news reports about Venice Beach in Los Angeles. What's more, Charlie seemed to add expressions like *"yeah, dog"* or *"cool, dog"* onto all of his sentences. As shyness was a concept that he didn't seem to grasp, Charlie didn't hesitate to flirt with the lovely young Dalmatian with her soft and sparingly spotted fur.

"When you get settled, be sure to bark me up, doggy babe. Or look me up on meetdogs.com. My username is 'playdog'."

Like her mistress, while she was well aware of her power of attraction, Barbarella was not really interested in games of seduction. She was flattered when a dog, from an impressive Great Dane to a reassuring Saint Bernard by way of a yappy Dachshund, came to sniff her a little too insistently, but that's as far as it went. She also let humans pet her. They just couldn't help it when they saw this lovely Dalmatian walking with her mistress in the Bois de Boulogne or on the streets of Paris. Because, like all Dalmatians, she was affectionate and liked the contact of people. But she had to admit that only her mistress and best friend Marianne counted for her.

"Careful or you'll end up an old maid," warned a white poodle whom she'd met in the park one day, while the poodle's partner, a brown and white Springer and Terrier mix played with their three puppies a few feet away. "You know, we females are all the same. We all dream of Prince Charming Paws. From *Lady and the Tramp* to *101 Dalmatians*, it's always the same story. Like Lady, I finally found my Tramp. As the good Dalmatian that you are, I'm sure that you dream of getting your paws on a handsome Pongo!"

Saved by her mistress calling her, Barbarella put an end to the conversation and left the rather indiscreet poodle behind.

Barbarella could only imagine the furry Charlie with his surfer locks over his eyes as a friend to talk or walk with, nothing more. Nor was she interested in the Shar Pei named Suntzu, her other companion on the plane. His masters, Ping and Lisa Wong, were restaurant owners. They had left the Chinese neighborhood of Paris to move to

Chinatown, where they had bought a restaurant shaped like a pagoda. Although blessed with a certain wisdom, Suntzu was a bit on the preachy side.

"Men like to say that dogs are just stomachs on four feet, but I beg to differ. Do dogs open restaurants? The wise dog is he who forgets that he has teeth," Suntzu told her, in his Chinese accent. "That said," added the Shar Pei, "if you're feeling peckish, come by and see me at the restaurant. My masters make the best fried rice in the world. And if you like egg rolls…"

"Personally, I prefer hamburgers and pizzas to your Chinese garbage," interrupted Charlie.

"Dogfucius said: 'When rubbed the wrong way, the clever dog is he who holds his tongue. Barking louder does not ensure victory.' And he declared this 2,000 years before Pluto was born and far before your poor sheepdog of a mother gave birth to your pudgy little self, my friend."

The amusing verbal repartee between the two males to claim their place as leader of the pack could have gone on forever. But for now, Barbarella had to leave her flight companions behind. Without even seeing her, she had recognized the light steps of her mistress and then her scent, mixed with a French perfume. Finally, Barbarella couldn't help scrambling around in her cage and wagging her tail frantically when she heard Marianne's gentle voice calling her as she approached. For the first time in 11 hours, the Dalmatian had an irrepressible desire to leave her cage.

5/ Los Angeles, California. LAX Airport.

Who has never felt a pang of anguish when waiting for their luggage on the airport's conveyor belt? It was true that spending a whole day or longer, crossing your fingers and hoping that your suitcase would arrive in one piece after traveling from one airport to another, was hardly enjoyable. Especially when the only change of clothes you had were carefully folded next to your toiletries. But, on this day, Marianne couldn't care less. Only one thing mattered: finding her Barbarella.

"They better not have switched destinations at the Charles de Gaulle airport," she worried during the flight. "What if the dog carrier took the wrong conveyor belt, headed for... Korea? A country where dogs ended up in bowls of soup, eaten with chopsticks!"

For Marianne, a so-called civilized country capable of eating man's best friend was potentially inclined to the most barbaric acts. Without imagining the worst scenarios, which she chased from her mind during the flight, Marianne also worried about the traveling conditions of her black and white protégée. So it was with a beating heart that she waited for Barbarella in the customs office.

Did her dog have a pleasant flight? What if some mindless employee had put her cage under mountains of luggage, cutting off her air and visibility for endless hours? Did Barbarella have enough water to drink? Was she afraid of being abandoned? All these questions that had eaten away at her during the long flight now took control of her mind once again. Fortunately, her maternal suffering would soon be over. Even before the door opened, she recognized the

little muted yaps that sounded like a puppy crying. But if Barbarella was crying, they were tears of joy.

Marianne wasn't even surprised that her canine love could sense her presence through the door that separated them. The dog and her mistress were so close, as if connected. Marianne thought that all the hugs they had shared had somehow joined them together. Animal and human as one. She laughingly called this "going chopping" due to all the moments they spent stretched out together, cheek against chops.

Then, the double doors opened and the cage appeared on a caddy pushed by an airport worker who looked like he had eaten so many hamburgers that he had become one. Super-sized. She was sure that his sweatiness and moldy cheddar stench indisposed the refined sense of smell of the delicate Dalmatian, who could very well have been named Duchess if this hadn't been the name of the famous heroine of *The Aristocats*.

"Miss Marianne Bonange? Could you sign the receipt please?" asked the man, as he wiped his forehead.

She would have to get used to this new language quickly. With the last formalities wrapped up, the French Dalmatian could finally set her paws on Uncle Sam's soil, even without a green card. And the dog and her mistress could indulge in a joyful long-awaited reunion. Barbarella's tail was crashing against the inside of the plastic cage so violently that Marianne was almost afraid she would hurt herself. Then the door opened, unleashing a torrent of Dalmatian kisses.

Nearby, an ageless-looking man watched the scene tenderly. He was sitting next to an Asian couple and their son who, like Marianne, had come to collect their immigrant pets. The door opened again. This time, a bigger trolley came out with two cages containing a Bearded Collie and a Shar Pei, respectively. This resulted in the same barks of joy, the same wagging of tails and the same happy paws on the walls of the cages. The same bursts of love between the masters and their dogs.

After putting a leash on Barbarella, Marianne said goodbye to the people she had become friends with during the long wait to get their pets, while the Dalmatian did the same with her traveling companions.

"See you soon, babe," said the Bearded Collie with a cocky wink.

"The road to Buddha is long, but short will be the road that will lead to our next meeting," added the philosophical Shar Pei.

"Hey, dog!" Charlie barked to Suntzu. "Take a chill pill!"

6/ Los Angeles, California. San Diego Freeway.

"Stop sulking, Boogie. We did a lot today," Eddy said, catching his dog's eye in the rear-view mirror of his convertible.

No reaction from the backseat. Eddy adjusted the rear-view mirror. The black and white mass stretched out on the seat next to the longboard seemed lifeless. Clearly, the Dalmatian was in a funk.

"Hey, Bogart. You hear me?" the driver continued. "We even had time to play at the beach. You went doggy surfing," he added to break up the tension. Doggy surfing being the canine equivalent of body surfing, i.e. surfing with your body, without a board. "Wow, what a great roller! It must have been six and a half feet high. There was actually a moment when I could only see your nose and ears sticking out of the foam. That was a tube worthy of Laird Hamildog, the Hawaiian Rottweiler champion who takes on the gigantic waves of North Shore. I'm proud of you, my little Bogart. This time, the two-tone dogs are taking over. My dog is the best!" he exclaimed. "I even saw a little royal poodle who was bowled over by your feats. If her mistress had unleashed her from her beach umbrella, I'm sure she would have raced into the water to join you. Don't tell me that you didn't notice that mutt. She was barking so loud they could hear her in Acapulco!"

Bogart suddenly sat up, the wind in the convertible whipping his thin ears around. His master had won. As he always did. This was no surprise, as he was THE master. His good master. His wonderful master. His man. Even though Dalmatians were known for their stubborn character, they never sulked for too long. And, for Bogart,

staying mad at Eddy, his human pal, for more than five minutes was simply unbearable.

Standing on his four paws, the Dalmatian graced Eddy's cheek with two friendly licks to show him that he agreed. It was true that their surfing session was fun. And it was true that the little poodle was doggylicious. For all these reasons, the Dalmatian could have stayed at the beach until sunset. The beach would have cleared out, little by little, and with his fur still dirty with sea spray, he would have sat down next to his master to watch the orange fireball set over Malibu Beach before gulping down a delicious plate of spaghetti carbonara, which his master made like no one else.

Partners. Pals. Friends for life. Bogart licked his cheek two more times to show him that he wasn't mad at him for cutting their beach day short. There would be others. That was one of the advantages of living in California.

He knew that his master couldn't help this scheduling problem. As usual, they could blame his master's friend and pseudo-agent Max, whom they had to help out again at the last minute. Because Eddy couldn't say no to his friends. And Max, in particular. Even though Max had a knack of getting him into tricky situations.

Bogart liked Max. He was his godfather, after all! But he had to admit that their chubby friend (who insisted that he was large-boned) wasn't exactly God's gift to mankind. Eddy and Bogart jokingly called him "Maximum Trouble."

Since college at UCLA, where Eddy and he had met, Max had detected Eddy's undeniable skills as a writer and screenwriter and decided to take his career in hand. So he became his makeshift agent right after college. But time went on and Eddy's screenplays hadn't gotten past the Hollywood assistants that Max claimed to know "even better than the fast food menus of Santa Monica" – and there was no denying that he knew his fast food.

Luckily for Bogart's food bowl, Eddy didn't depend on his friend Max to earn a living. He used his talents for a small film magazine and the modest monthly payments that they received allowed them to get just enough gas for the old Porsche to take them surfing in Mexico, buy DVDs and fill the fridge and cupboards with enough food to make the spaghetti carbonara that Max, who came over for dinner several times a week, adored.

When the mobile phone started to vibrate and Max's name came on the screen, the Dalmatian immediately smelled trouble and tried to hide it under the beach towel, but too late. The beach dog had felt the bad vibrations…

"Nice try, pal," said Eddy. "But you know that if Max calls, it's because he needs us. That's what friends are for, Bogart," he added, true to his nature, before answering the phone.

"It's about time you picked up! I've been trying to reach you for over an hour," complained Max, without bothering to say hello first. "I thought Bogart had hidden your phone again."

"Hey, Max," answered Eddy, looking tenderly at his dog, who seemed to be begging him to hang up as quickly as possible. "Thanks for asking, I'm fine and so's Bogart. How nice of you to ask."

"Sorry, man, I was freaking out. You HAVE to do me a favor. It's a question of life or death."

"If you need money, I'm sorry, Max, but things are tight this month. I'm still waiting to hear from Warner about the 15-episode series that 'my' agent assured me that he sold them six months ago. Do you remember *Lassie in the City*, the new adventures of the famous collie in New York that the producer supposedly signed off on? And I just finished paying for the repairs on my Porsche, after this same agent shortened its hood by about 8 inches the last time he borrowed the car from me."

"Don't be like that, Eddy," responded Max nervously. "I'm still waiting for an answer from my friend at Warner. It's just that he kind of changed his mind since the agreement. It seems that dogs aren't as in right now for TV series. He suggested turning your four-footed hero into a panda."

"A panda called Lassie who lives in New York?"

"Well, yeah, why not? After all, I named my goldfish Angelina and Brad."

"Need I remind you that pandas live in Asia and eat only bamboo leaves? Not hot dogs sold on the streets of Manhattan."

"And if you're going down that road, they don't do kung fu either. I'm sure we can find some bamboo in Central Park. You're supposed to be the talented screenwriter, not me."

"I'm also the unfortunate owner of a smashed Porsche…"

"Oh, that's low! Really low, Eddy. You're hitting me under the belt. You know that I feel awful about what happened to your car. Seriously. I promise I'll pay you back with my share once I've sold one of your screenplays. But I remind you that it's your fault that I borrowed your convertible. I couldn't show up at an important meeting with a producer to sell one of your films in my old jalopy. That would hardly have made a very good impression. We're in Hollywood, man, not Bollywood!"

"That's funny, because the insurance report mentions a collision with a trash bin at 4 in the morning after the driver suddenly fell asleep at the wheel."

"Insurers are all liars and thieves, Eddy. Who are you going to believe? Those vultures or your old friend Max? But, rest assured, this time I'm not calling to ask you for money. Actually, my car had a little breakdown," admitted Max as he looked at his old VW Bug, which was smashed into the back of a truck on the freeway. "Nothing serious, but unfortunately, I won't be able to use it for, umm, a little while…"

"I hope you're not actually asking me to lend you the Porsche again, Max."

"Of course not, Eddy! Although…" Faced with his friend's silence, he didn't take this train of thought any further. "Actually," he said, changing his line, "I wanted to ask you to run a little errand for me."

"What do you want me to get for you," asked Eddy, always ready to lend a helping hand despite everything. "If you promise me that it's not 'exotic' women's lingerie like last time, then it's fine by me."

"Don't worry, Eddy. You won't have to bring me anything… weird. Actually, you have to pick up… someone."

"Someone?"

"Yeah, a person. A human being."

"When and where?"

"At the airport. Soon. She'll be landing soon."

"She?"

"Yes. Marianne Bonange, a French film student from Paris who I offered an unpaid internship to. She'll be the assistant to one of the most brilliant agents in Hollywood for two months."

"And what does your future slave look like?"

"Well, actually, on the school website where I recruited her, she put a photo of Fiona instead of her own."

"Fiona?"

"You know, the princess from Shrek."

"The one from the beginning of the film? Before her transformation?"

"Uh, no. The fat green one... I think she was kind of making an intellectual joke about her unfortunate appearance. The poor girl must have a good sense of humor. This will be an advantage when it comes to correcting the screenplays that you give me."

"But I don't need a French student doppelganger of Shrek's wife to correct everything that I write, Max."

"Oh yes you do! WE need her very badly. If WE can manage to sell your films to the best studios. Unfortunately, Bogart won't correct OUR manuscripts," added Max, while the Dalmatian tilted his head to the side, looking warily at the phone as if he had heard everything. Which was actually the case, as a dog's hearing is particularly developed. "Go on, get over to LAX. There's no time to lose, Eddie. You should be able to recognize her, easily. Imagine a green *Ugly Betty* who speaks with a French accent. Oh, there's one more thing," he added.

"What now, Max?"

"Well, I had planned on setting her up in my studio while I lived at my office on Hollywood Boulevard. Everything was completely organized – you know how I am. It's just that..."

"WHAT NOW, Max?"

"Well, I don't really have a place anymore. My landlord kicked me out last week, claiming that I was a little late paying my rent... Come on, it was only six months... Stingy jerk!"

"Okay, what hotel should I take her to?"

"Very funny, Eddy. The internship agreement includes lodging for the student. There's no way she's going to pay for a hotel. No, WE don't have the choice. She and her dog have to move in with you for two months."

"Dog? What dog?" Eddy asked weakly, as Bogart looked on, not in the least bit happy about sharing the small Malibu apartment with a stranger and her dog.

"Thanks, Eddy. I knew I could count on you. You're a lifesaver." And with that Max hung up and turned off his phone for the next few hours…

7/ LAX Airport, Los Angeles.

That must have been the fifteenth man that Marianne had shooed away. It was always the same thing. Some guy came up to her and Barbarella, who was obediently seated on her hind legs next to her mistress and the caddy with the luggage and the plastic carrier on it. Marianne smiled nicely at the stranger, hoping it was Max, the famous Hollywood agent whom she would be working for. Unfortunately, for more than an hour, she had been pacing the arrival hall of the airport and the only men she had met were incurable flirts whose unsubtle advances she had to turn down, often accompanied by the growling of her dog when these badly behaved men became too insistent or even aggressive.

Marianne had tried to call her future boss on his mobile phone many times, but it went straight to voicemail. "Hello, you have reached Max Lose, agent of the most bankable stars of today and tomorrow. Screenwriters, actors and directors, if you want to set foot on the red carpet of the Oscars each year, leave a message after the beep. The following message is for Tom Cruise, Leonardo di Caprio, Reese Witherspoon and Steven Spielberg: please stop calling. I told you that I can't work with you for the moment."

As for the lovely Dalmatian, she had caught the attention of the airport's German Shepherd security dog. "I would have loved to take you to my kennel for a body search, babe, but I'm sure that such a pretty dog has nothing to hide behind her irresistible black spots," the police dog told her. Then he strutted off, his ears perked straight up, with the same proud stride as his two-footed partner, a young blond

officer who didn't deign to take off his mirror Aviator sunglasses when talking to her mistress to ask if she needed assistance.

Bogart noticed them first. Or, to be more precise, he saw the dog first, and then her mistress. You had to be completely blind not to see her and have your nose completely stuffed up not to smell her. She was a Dalmatian, like him. Maybe her fur was less spotted than his, which made her even whiter, purer and more delicate, he thought, while examining her from a distance. She was thinner and slightly smaller than him, which made him want to protect her and brought out his pack leader mentality. Her deliciously curled lashes seemed endless to him and her nose was exquisitely fine. As for her smell, a subtle mix of flowers and spices, mixed with her mistress's fragrance, a French perfume to be sure, even from 600 feet away, Bogart could have rolled his whole body in it.

Amongst the busy crowd in the airport hall, Bogart could only see and smell her. The Dalmatian was sitting demurely and gracefully next to her mistress, seeming to wait for something or someone. Maybe the dog of her life? Bogart felt his heart beating wildly in his chest. Even now, he couldn't control his wagging tail, which whipped through the air from left to right like a mad metronome. While pulling on his leash, he couldn't help letting out a first bark, which he tried to muffle, and then a second louder one which he couldn't control and which, despite the hubbub of the airport, carried his young but adult Dalmatian voice across the hall.

As was often the case, her nose warned her ahead of time. It started with a slight smell of hazelnuts, which she sensed coming from the big airport hall. Yes, that was it, the hazelnuts that she sniffed when her mistress took her walking in the woods in autumn, the season when the French forests draped themselves in warm tones before winter. Then, a few seconds later, she heard a muffled bark followed by a louder one, as powerful as the roar of a lion in the savannah. She turned her head and saw him. Her black and white double. A magnificent Dalmatian barking at her from a distance.

If she hadn't held herself back, Barbarella would have also started barking before racing off to him. But she did nothing. She forced herself to remain calm, trying especially hard to control the movements of her tail, which was betraying her emotion. She would have loved to give in and replay the scene from the old French film

that she and her mistress knew by heart, as they had seen it over and over together on the sofa of their living room: *A Man and a Woman*. For one second, Barbarella imagined their leashes gliding in slow motion from the hands of their respective owners and then, still in slow motion, she saw herself running after this unknown dog. The people milling about in the airport hall just seconds earlier would seem frozen in place. She could even hear the melody in her head: "shabadabada, shabadabada…" *A Dalmatian and a Dalmatian*.

But the canine remake stopped there. In her dreams. And Barbarella stayed obediently seated by her mistress. Because there was no way that a Dalmatian born in one of the best kennel clubs in Europe, the Brittany kennel club "De La Lorette en Cornouailles," near the city of Quimper in France, could be called a tease. But the superb Dalmatian was already approaching them at the speed of a greyhound on a racecourse in Florida, pulling his master along behind him. His master seemed to be on rollerblades, which wasn't surprising for a Californian according to the reports on Venice Beach that she had seen.

Actually, the Dalmatian's master was not on rollerblades. After tripping over a suitcase, he had landed on some teenager's skateboard. The furious teen was chasing the strange procession, which was rushing through the crowd. On the accidentally borrowed skateboard, the Dalmatian's master was apologizing to everyone he bumped into while trying in vain to make his dog stop. The scene was both comical and… romantic. By replacing the skateboard with an old bicycle, the scene could have been plucked straight from *101 Dalmatians*.

Having lost control, the master tried to regain his authority despite it all, seeming to forget that once a Dalmatian has set its mind to something, nothing can stop it. Especially a Dalmatian… in love?

"Bogart, I said stop!" When he was mad at his dog, Eddy called him by his full name. "Boogie" was for calmer moments.

This is how she learned his name. A lovely name that suited him well. A movie star name. A Hollywood star. Bogart. About two years old. Just like her… "Shabadabada, shabadabada…"

"Look at that beautiful Dalmatian, Barbie. He looks like a male version of you," pointed out Marianne. "He's gorgeous. Did you see his nose? It's just like yours, in the shape of…"

... A heart. Her mistress was right. A lovely black heart perfectly formed on his confident face. All set on a strong head. Over a strong, wiry body sparingly spattered with spots. A Californian who was impossible to resist. And the two-footed man balancing on his skateboard, hanging on to the leash like a wakeboarder in a long slide wasn't half-bad either, proving once again that the old adage "like dog, like master" was true. Much more interesting than all the idiots who had come to bother them for the last hour. At any rate, a man who chose a Dalmatian for a companion couldn't be a bad person. She looked at her mistress, who understood her at a glance.

"Yes, I agree, his master's not bad either. But he's a little old to be skating, don't you think?" she barely had time to say before, just like in a movie scene, the two leashes got mixed up, winding the two humans together and knocking them over. A great canine classic. Coming almost nose to nose, the enterprising Bogart asked her name.

Near them, a group of people watched amusedly while the teenager recuperated his precious skateboard while insulting the "old retard who had tried to steal his board." Embarrassed, Bogart's master removed his hands, which had ended up on Marianne's waist in the confusion, and apologized over and over, saying that he was "so sorry."

"I'm the one who's sorry," answered Marianne, who, stretched out on this charming man, tried to get up, without being able to, as the leashes were still rolled around their legs.

"Your accent..." said the young man. "Are you French?"

"Bingo! And it's my first time on American ground. Literally," she added, before breaking into laughter and making him laugh too.

"I guess I didn't have time to introduce myself. Marianne."

"Marianne... Bonange? Actually, I came to pick you up. But without the, let's say brutal, assistance of Bogart, I don't think I would have recognized you. I thought you'd be... different."

"Different how?"

"Maybe a little... greener."

"Excuse me?"

"You know, like Fiona."

"Fiona?"

"Yeah, Shrek's fiancée."

"Oh yes, my profile photo," she said, laughing once again. He found her laugh simply delicious. "That was just a joke. To be sure that people recruited me for my resumé and not my looks. Are you disappointed?"

"Not really."

"And you introduced me to Bogart. Or should I say *he* introduced *us* in a most... energetic and original way. Now it's my turn to introduce you to my best friend and confidante: Barbarella."

"Hello, Barbarella," Bogart's master said kindly, still lying down on his back. He petted the Dalmatian's head and she answered by licking his cheek. The man's skin was soft. And he had petted her nicely. And he smelled good. A nice manly smell in which the dog could catch a hint of seawater. The same smell that she caught from the Dalmatian, whose scent was mixed with hazelnut.

"You must be Max," said Marianne after their two dogs finally let them get up.

"Yes. I mean no. Actually, I'm Eddy. Eddy Fellow. Max's friend. And this is Bogart. But, I guess you know that already."

"Your master seems smitten," Barbarella told Bogart.

"You're right. I've never seen him like this before. I don't think he expected your mistress to be this pretty. Just like her dog," added Bogart, shooting a loving look at the young Dalmatian, who looked away, embarrassed.

"Actually, Max couldn't make it here himself," continued Eddy. "You'll see that this happens to him all the time. You'll probably have the unlucky chance of meeting him... tomorrow, if everything goes well. In the meantime, he asked me to come get you. I'm sorry I made you wait. Max called me at the last minute. Bogart and I had just finished surfing."

"And how did you get here? On a skateboard?"

"No, the skating wasn't exactly planned. My car is parked outside. That is, if it hasn't been towed already. It's not very big, but if we put your bag inside the cage and the cage on top of the longboard, I think we'll manage. The two dogs can squeeze together," added Eddy, while the Dalmatians shared a knowing look. "I'm counting on you to make room for your new friend from France, Boogie."

"All the room that you want, babe," thought Bogart, wagging his tail. "*Mi casa es tu casa.*"

8/ Los Angeles, California. Malibu Beach.

"I asked for my Diet Coke with no ice. That doesn't seem very complicated. Do you want me to get a stomachache during the video shoot or what?!" Jenny Palace shrieked at the young assistant who raced off to get her a new drink as fast as Wile E. Coyote chasing after the Road Runner. The unlucky assistant knew that if he wasn't back with the glass in less than three seconds, he could say goodbye to his new job. "Do you want the entire beach to hear me farting during my song?" Jenny continued screeching, without the slightest hint of embarrassment. "Do you want the sea to fill up with bubbles while the camera is filming me swim? Everyone knows that ice cubes give me gas. My agent included it in all my contracts. I could sue the production for that alone!"

"But darrrling, you know-a verrry well dat dee prrroduction ees you. You cannot-a sue yourself, *bella ragazza mia*," cooed Alberto, her personal assistant for the last six months and almost two days. A record, considering that all the close collaborators of the billionaire starlet had been fired after two months' time.

"And stop speaking with that stupid Italian accent, Alberto. You know as well as I do that you have not once set foot in Italy and that your family has been in Texas for at least five generations. What's more, a little bird told me your name isn't Alberto Vaniti but Al Vanity, despite the horrible carpet spilling out of your shirts, your slicked-back hair and your cheap Mafioso look."

Alberto slipped on his big sunglasses, which really made him look like a fly, as if trying to hide behind them. If he could have sunk into the sand right then and there, he would have.

"You-a, ahem, you don't think Gucci gained a little weight lately?" he asked in a falsetto voice to change the subject, while petting the skinny Chihuahua who seemed lost in his fat hairy hands.

"Oh my god! You're right! That stupid bulimic mutt must have gained at least a gram. I'm going to fire that **** canine nutritionist who's costing me a fortune. No, call her right now and tell her yourself that she is no longer a part of my staff."

The exemplary employee, Alberto dialed the number immediately on his cell phone.

"Cindy? You're fired, honey. *Basta cosi* and *arrivederci*," he concluded, before hanging up.

"Ah, finally!" said Jenny to the young assistant who came back, trembling, with a new Coke. "Actually…"

"Yes, Miss Palace?"

"You're fired, too. Shoo, get out! Out of my sight! I can't believe that everyone has decided to ruin my life today," she added, before downing her soda in one go, sucking it loudly and thirstily from a straw. "The Italian" watched her, while shaking his head.

"What? When you move your head like that, you look like a batty old Sicilian crony, poor little Alberto."

"You shouldn't drink so quickly, dear," Al Vanity, alias 'Alberto Vaniti' or 'Alberto V' or even 'Alberto V of Beverly Hills' or 'Alberto V, personal assistant of Miss Palace,' dared to say. Then, without realizing what he was doing, he rolled his eyes. Big mistake. While sucking up the end of her glass even more loudly, the starlet shot him a questioning and not exactly kind look.

"What does that mean?" she added, imitating him rolling his eyes.

"*Bene*, you know…"

"No, I don't know, Alberto."

"Because of your little problem."

"What problem, Alberto?"

"What you just said."

"What did I just say?"

"Well, your… How can I say this," he hesitated, well aware that he should have kept his mouth shut. "Your… Pftt." He made a slight farting sound, looking left and right to make sure no one was listening.

"My... Pftt?" repeated Jenny. "I have no idea what you're talking about. Did you drink too much Chianti today, Alberto?"

"You know what I mean, my Star (she loved being called a Star). Your PFTTTTT." This time, he made an enormous sound that caught the attention of the technicians and extras all around them.

"Gross, Alberto," she said, grimacing in disgust. "Stop being so revolting. And you're sweating like a pig. Wipe your face, it's making me sick."

"Actually, I didn't mean anything," concluded the assistant, wiping his forehead. "Oh, I think the director is ready to shoot *Ma Bellissima!*" he exclaimed, pointing to the team bustling around a young playboy seated in a director's chair. Saved by the clapboard. At least for the next few hours, Alberto would keep his precarious job as Jenny Palace's full-time personal assistant and mistreated slave.

9/ Malibu Beach. 600 feet away.

Not far from the shoot umbrellas for Jenny Palace's latest video, the mood was much more relaxed and, one could even say, festive. Marianne, Eddy and their two Dalmatians had all woken up on the right side of the bed this morning.

After their sudden and explosive meeting at the airport the day before, everything was going smoothly. The trip to Eddy's house at about 20 miles an hour, so as not to lose Marianne's luggage, the cage and the longboard on the way, had given them time to get to know each other in the old Porsche convertible. Eddy and Marianne talked about their shared passion for cinema, animals in general and Dalmatians in particular. Each one seemed to want to learn everything about the other person's life, as if making up for lost time.

These humans were so cute, thought the two dogs as they watched their respective masters fall in love with each other without even realizing it. Because, for the two Dalmatians, everything was crystal clear from the very moment they smelled each other, before they even caught a glimpse of each other's hide. It was love at first smell. When the time came to eat their spaghetti together, Bogart wouldn't have to resort to the spaghetti trick from *Lady and The Tramp* to seduce Barbarella. They were already very close. And the little French dog became smitten with the Californian Dalmatian from his very first bark. Nestled fur against fur in the backseat, the Dalmatians were delighted to share the tight space together.

"I think Bogart's in love," commented Eddy with a quick glance in the rear-view mirror.

"And I don't think my Barbarella minds. Right, Barbie?" Marianne responded, looking behind her. "Don't you think they're beautiful together? They…"

"Match."

They had a wonderful evening together. Eddy made his delicious spaghetti carbonara dinner for his French guests and everyone loved it. There wasn't one drop left in the plates or dog bowls. And the sun setting over the ocean, seen from the apartment's small terrace, was just as gorgeous as the two new arrivals could have hoped for. With this marvelous Californian light that had so impressed Marianne when she watched the movies shot in Los Angeles.

After endless discussions, it was finally time to go to bed. Eddy, being the perfect gentleman, had offered his bedroom to his guest. He slept on the sofa bed, whose springs were almost as worn out as the shock absorbers of his Porsche. For the first time in a long time, he didn't sleep with his Dalmatian that night. And Marianne was surprised to wake up the next morning without Barbarella at the foot of her bed. When the first rays of the dawn sun appeared, they lit up two furry black and white bodies stretched out next to each other on the terrace.

But now the two Dalmatians were awake. In the waves of Malibu Beach, Bogart was introducing Barbarella to the joys of doggy surfing, while his master tried to keep Marianne balanced on his longboard. Laughter and the clinking of glasses and dog bowls filled the air.

From his towel, Max, who had joined them at the apartment for lunch, watched the scene amusedly while eating some pistachio ice cream. He wondered what they saw in water sports – and in sports in general.

Almost done with his ice cream, the courageous Max was getting ready to partake in what he called meditation, i.e. what others called a nap, when his attention was caught by a disturbance on the beach. At a close distance, a crowd was moving towards them and raising a ruckus. First, he only noticed people in swimsuits, clustered like a colony of bees around a hive, yelling and jumping around.

Surrounded by 15 or so bodyguards with headset earpieces, sunglasses and dark suits, despite the heat, Jenny Palace ran towards a cameraman, the wind blowing through her hair. She was wearing an

orange swimsuit, a perfect replica of the one worn by Pamela Anderson and the women lifeguards on the famous series *Baywatch*. Suddenly, she stopped when she heard her mobile phone, which she had hidden behind the orange lifebuoy that she held in her hand.

"Cut!" cried Ripley Scotch, the director, completely fed up. "I can't believe it. This is the tenth take that we had to cut short because of this **** phone. Jenny, sweetheart, can't you turn it off for just one little hour? Just so we can finish shooting this video today?"

As an answer, she stuck out her tongue and made a rude gesture.

"Tony, oh my god, you finally called! I must have left at least 200 messages with your stupid secretary since yesterday! Did you finally find what you needed for my next car?" she asked.

"Yes, all the dogs were sent to the agreed-upon location."

"Perfect, when are you going to start the... work?"

"Soon, when I go back to the island."

"What do you mean? Didn't you stay there to work on the skins?" she suddenly whispered.

"No, actually, I had to take your jet to come home. I'm in L.A. again."

"My birthday is in two weeks!" she screamed. "My car made from Dal... I mean my black and white car..." she corrected herself, realizing that a large crowd was watching her, "...HAS to be finished for my *Black and white party*," she murmured.

"It will be ready, Miss Palace. Don't you worry. I just need to find one last Dalmatian. When I took the measurements of each dog that arrived on the island, I realized that I was missing the equivalent of one more dog for your car to be perfect. I redid all the calculations on my computer, but each time I came up with the same result. A few dogs must have lost weight during the journey. I can't see any other explanation. That said, if you want, we can skip the skin for the steering wheel and the gear shift."

"And put what in its place? Chihuahua?" Right then, Gucci, held on a leash by Alberto V, started trembling like a leaf with all his skinny little body.

"But-a why are you-a shaking, Gucci?" the assistant asked the dog.

"There's no way we're skimping on the finishing details, Tony. Find something fast to finish the customization. That shouldn't be difficult for a pro like you."

"I remind you that it wasn't an easy task to find 186 Dalmatians. I had to steal some in almost 45 states to stay under the radar. I had to go all the way to Alaska to steal the last one. My men and I almost got caught several times. I heard that the FBI even started a national inquiry."

"You should have just bought them. After all, I'm certainly paying you enough to do so."

"That's not the issue. The breeders only sell puppies. When they're two months old, their spots haven't completely appeared yet and I needed four times as many to cover your Bentley. And you didn't want to wait for them to get bigger. As for the Dalmatian owners, they don't want to give up their animals. And at any rate, it would have been impossible to buy them, because that would have left a trace. Remember the scandal that broke out for your car covered in hair that we bought from dirt-poor young women? I'm not sure that the animal rights associations and the feds would have appreciated that."

"Okay, Tony," interrupted Jenny, seeing that the director was on the verge of a nervous breakdown. "Find the last one soon, fly it there in my plane and start working immediately. I want my car for my birthday, got it?"

10/ Malibu Beach.

Bogart was the first to hear the shriek coming from the Ocean, farther up the beach. He instantly turned in the direction of the noise and froze, in the position of a hunting dog from a 19th-century English etching. Barbarella, who hadn't strayed one paw from the Californian Dalmatian all day long, struck the same pose with her tail straight out. Then, they both started barking in the direction of the ocean.

"Don't worry, Bogart. It's just a film shoot," his master reassured him. "Frankly, you should be used to them by now. You live in L.A., pal. The city of the Silver Screen!"

But unfortunately, the dog had already decided to listen to his courage rather than his master. Believing that a woman was in danger, the intrepid Dalmatian was galloping in the sand, slipping in and out between the towels, followed close behind by Barbarella.

"No, Bogart! Heel!" yelled Eddy in vain.

"Barbarella, heel!" cried Marianne at the same time. With the same lack of results.

They both realized that once the Dalmatians had set their minds to something, nothing would stop them.

The Dalmatian owners had no choice but to run after their companions. They raced between the people who had come to spend a calm Sunday at the beach and who were visibly annoyed to find themselves covered in sand after the dogs and their masters sped by.

"No *way*," said Max, who had decided to take his time finishing his ice cream and not bother with the shenanigans of the dogs. "That screeching woman in orange… Why, it's Jenny Palace!" he gasped, knocking the rest of his ice cream onto his stomach as he stood up in

surprise. "Quick, my business cards," he said as he dug through his backpack. "Business is business! I love L.A.!" hummed the agent before running after his friends.

Ripley Scotch, the young playboy-perfect director of Jenny Palace's video, finally started to relax. The camera had been rolling for at least two minutes with no interruptions. This was a record since he had started the shoot with *the poor dirty rich girl*. And if her mobile phone started blaring out the noisy ringtones that Jenny Palace downloaded all the time, she wouldn't be able to answer it. As she needed to jump in the water for the video, Jenny had finally agreed to hand her mobile phone over to her assistant, the pseudo-Italian Alberto, whose fake accent made the young director's skin crawl.

In the water, the billionaire singer was yelling, *"Help me! Help me! I'm famous!"* – the chorus of her next album, simply and modestly entitled *"Jenny."* She was still jumping around and singing, flailing her arms in the air with her orange float in one hand, when the two black and white dogs exploded into the shot and dove into the water towards Jenny Palace.

"Oh my god. This shoot is cursed!" cried Ripley Scotch, completely fed up at this point. "Cut! Again!" he added, while the first dog tried to bring the singer back to the shore, followed close behind by the second dog.

The trio was soon joined in the water by a young couple. Close behind were four of the black-suited bodyguards paid to protect the billionaire starlet, wading in the water in their ill-chosen outfits. Finally, to complete the strange scene, which was turning the video shoot into pure chaos, a chubby man in extra-large floral swim trunks dived into the water after them, waving a card and yelling something incomprehensible.

"Darling," the director asked his assistant, who looked more like a top model, in a flat voice, "Can you get me an aspirin? I just got the worst headache."

The two Dalmatians were now flanking the young temperamental singer. Normally, she would have gone into a humongous fit. But, on the contrary, she seemed relaxed and almost delighted to return to the beach with the two dogs. She even seemed to find the presence of these two Dalmatians… heaven-sent.

Her calm attitude amazed the director, Alberto and everyone present, as they were all used to Jenny's despicable character. Only one witness to the strange scene wasn't duped by the starlet's little act. A dog no bigger than a rat, grotesquely dressed up for the occasion in a swimsuit the same color of orange as Jenny Palace's, with the word *Lifeguard* printed on it. The Chihuahua had already guessed what his young cruel mistress was scheming. A purely evil, Machiavellian plan. As was often the case, Gucci started shaking when he thought about the future of the two Dalmatians.

"Don't bother these adorable pooches and their masters. The cuties thought I was drowning," said Jenny to her bodyguards, who approached the little group with a threatening look, their trousers soaked up to their thighs. "They're so adorable! And this just proves what a good actress I am. Right, my little Ripley?"

"Of course, darling," answered the director without conviction before swallowing another handful of pills. "You're the best." He weakly gave her a thumbs-up as a sign of encouragement, while everyone went back to the beach.

"Don't you agree, Alberto?"

"Do I-a agree, *bella ragazza*? Of course. You are an incrrredible actress. Carmen Electra better watch out."

"Carmen Electra?" she questioned, pouting. "Don't you have a better example, Alberto?"

"Uhh, Miley Cyrus?"

"She's like two-and-a-half years old!"

"Lindsay Lohan...?"

"Bring towels on the double for my new friends," ordered Jenny Palace in an exasperated voice, while Alberto, who had rushed to her with a towel as soon as she got out of the water (throwing poor Gucci onto the sand in his wake) was vigorously rubbing his boss. "Ow! You idiot, are you trying to rip off my skin or what? Do I need to remind you that my body is insured for over 200 million dollars and that each of my beauty marks is worth three times more than your annual salary?"

"*Scusi, bella...*"

"I don't want your *scusis*. That's enough Italian for the day!"

"Okay, sorry!" he answered, without the slightest accent.

"But keep calling me *Bella*..."

"Thanks so much, but we don't need towels. As you can see, Marianne, Max and I are in swimsuits and, as for Bogart and Barbarella, they're already drying themselves," said Eddy, pointing to the two Dalmatians, who were shaking themselves with synchronized movements, spraying Alberto's silk shirt and pants with droplets of water.

"Well, aren't they funny… and beautiful," added Jenny Palace. "Don't you think so, Alberto?"

"If you say so," responded the assistant, who didn't seem to appreciate seeing his clothes get wet by the two dogs.

"What a beautiful male. His dimensions are so… perfect. And his fur is so soft. He'd be perfect for the steer…" She was already picturing herself behind the wheel of her new Bentloyce entirely customized with Dalmatian skin and automatically mimed driving a car… "Umm, for my next video," she continued, as she caressed Bogart.

Bogart, delighted and as trusting as ever when it came to humans, let her pet him as he wagged his tail. But Barbarella didn't seem to appreciate the little act put on by the young billionaire. A female dog's intuition.

"Ruff!" she barked, glaring at Jenny Palace, who continued to flatter the Dalmatian.

"Be nice, Barbie," warned Marianne.

"His master's not half-bad either," added the starlet, shooting a seductive glance at Eddy and smiling.

"Actually, maybe you're not wrong, doggie dear," whispered Marianne to her Dalmatian, who had turned towards her mistress. They exchanged a knowing look.

"Jenny. Jenny Palace," she introduced herself, holding Eddy's hand a little too long. "But maybe you already knew that? And what's your name?"

"We already recognized you, Miss Palace," yelled Max, pushing aside two bodyguards who blocked his path. "That's Eddy Fellow, the crème de la crème of Hollywood screenwriters and the most creative and talented writer to the east, south, north and west of the Mississippi! It's a pleasure to meet you," he huffed, separating their hands to grab Jenny's hand with his own, to Marianne's great relief. "And I'm Max. Max Lose. Agent to the stars. I'm a bit overbooked

right now, what with Britney's caprices and Beyoncé's whims to cater to – you know how it is. Not to mention Tom Cruise," he added, "who won't stop bugging me to help him boost his career, poor guy. But for someone with your talent," he pointed out, thinking of Jenny Palace's immense fortune, "I could make an effort and find some time. A little time.... Or a lot... I mean, all the time that you need."

"Do you have a business card, Mr. Lose?" she asked, not even pretending to care. One of her specialties as a professional pest.

"Actually, umm... You have it... umm... in your hand," answered Max, pulling his hand away and leaving his business card stuck to the young woman's palm. "I'm as professional as it gets," he added, flashing a fake toothy smile and looking at Eddy, who, obviously embarrassed by Max's legendary ballsiness, rolled his eyes. "And this is Marianne Bonange, my assistant," continued Max. "Marianne arrived last night from Paris."

"Paris?" repeated Jenny, pronouncing it "pa-reese", as if the name recalled an important memory from some other life.

"Paris. The city. Marianne is French," explained Max.

"Well, *enchantée* then," she enunciated in French, while barely deigning to shoot a quick, cold glance at Marianne. "That's how you say it in your language, right? And you, my handsome guy, you must be Bogart," she continued, her voice syrupy again, as she leaned over towards the Dalmatian, without even giving Marianne the time to answer. "Bogart, my hero," she cooed, petting the young Dalmatian again, while Barbarella and Marianne exchanged an exasperated look. "And you, my pretty one, you must be Barbarella. You're smaller. With less fur," Jenny continued, turning towards the dog, who started growling, showing her fangs. "My, my, you don't seem very friendly, do you? Are French girls the jealous type?"

Marianne was about to say something when the director interrupted them, wanting to start the shoot again while there was still light.

"You can't imagine how happy I am to have met my new friends. You and your Dalmatians just lit up my day. Now that I have Mr. Lose's number, I'll get in touch real soon with the most seductive young screenwriter of L.A. and his wonderful Dalmatian," concluded the starlet, already dreaming of her next car covered in Dalmatian skin, before letting the little group move away.

"The magazines are bogus. Jenny Palace is actually pretty nice," Eddy innocently remarked, while Bogart agreed, wagging his tail.

"And, more importantly, she's incredibly rich and extremely famous," added Max. "A girl like that could open all the doors of Hollywood! One word from her or, even better, your photo with her in a celebrity magazine, and your career is set. And if the media hints at an adventure between the two of you, bingo! Did you see the way she was looking at you?"

"Max, you are really sick. And I thought you ALREADY knew everyone in Hollywood," shot Eddy.

"Well, of course. Of course I know everyone in Hollywood. There's a reason you chose me for an agent. I mean… almost everyone in Hollywood… As Howard Hughes said, 'It's time to take action'," he changed the subject. "We're not going to wait for her to call us," said Max. "No way! Take my word for it. Marianne, tomorrow morning, you get an appointment for Eddy and me with Jenny Palace's secretary. This will be your first job for me. I already smell the glory, my friends. Get ready for the red carpet and the Oscars! Hey, I'm taking you all out tonight to celebrate! Eddy's paying, of course, because he's about to become the most fashionable screenwriter in Hollywood."

Marianne nodded half-heartedly. She couldn't think of a worse first task. Without knowing why, her wonderful day at Malibu Beach was spoiled by this strange encounter with Jenny Palace, whose scandalous international reputation seemed largely justified. She looked at Barbarella. The young Dalmatian stared back at her with a tender, understanding look. In one glance, Marianne was sure that her dog knew exactly what she was thinking. And while Marianne couldn't say that she was exactly objective when it came to Jenny Palace, maybe, just maybe, because she was jealous, she trusted the judgment of her faithful companion. Barbarella's instinct, in terms of situations and humans, was always right on the money.

11/ Chinatown. Downtown Los Angeles.

The Pagoda was located right at the heart of Chinatown, in the center of L.A. It was a delightful spot and the name wasn't just for show; the restaurant was actually shaped like a real pagoda like one might see in Beijing or Shanghai. It was Marianne who had chosen this restaurant, which had been taken over by her new friends, the Wongs, since their arrival from France. She had met them when they were waiting for their dogs after the flight. Once Eddy and Max were introduced, the Wongs gave them a warm welcome. They were obviously touched that the young woman had come to visit them so quickly. Plus, this was their opening night. Marianne brought Barbarella, as the Wongs had kindly invited her to do so.

"I also told my friend that he could come with his Dalmatian, Bogart. I hope that it's not too much to have two dogs in your restaurant."

"On the contrary. They're so beautiful with their matching tags," said the restaurant owner, pointing to the two pendants hanging from the Dalmatians' collars, purchased several hours earlier by Eddy. Two big, identical B's, except for the color. A blue B for Bogart and a pink one for Barbarella.

"I'm glad you brought your four-footed friends," Mr. Wong continued. "That way people will stop saying that Chinese are dog-eaters. At The Pagoda, the dogs are behind the plates and not on them," he laughed. "Bogart – that's so Hollywood," commented Mr. Wong, petting the Dalmatian who wagged his tail while eyeing the plate of shrimp chips that the restaurant owner was holding.

"Actually, the Mexican friend who gave him to me when he was only two months old wanted to call him Bamba. But when he was just a puppy, he would whine at the end of *Casablanca* with Humphrey Bogart and Ingrid Bergman, every time I watched the film. So I thought Bogart would suit him better. Boogie also loves kung-fu movies with Bruce Lee, Jackie Chan and Jet Li. I could have called him Bamboo…"

"Bamboo bends but never breaks. Instead of being named after a famous actor, you would have been christened like a wise warrior, my Dalmatian friend," Barbarella and Bogart heard, while the humans only noticed slight barking. It was Suntzu, who had just made his presence known, perched on a high stool behind the bar decorated with an imposing dragon.

"Marianne, you must recognize Suntzu, our Shar Pei," said Lisa Wong.

"He's as adorable as ever with all his wrinkles," answered the French woman. "Hello, Suntzu."

"Greetings to you, inestimable French human beauty, mistress of the no less magnificent celestial and canine wonder known as Barbarella," he barked, to Bogart's surprise and to the extreme delight of the female Dalmatian, amused by the Shar Pei's strong accent and traditional speech.

"And just as boring as ever with his proverbs and sayings pulled straight from a bad Kung Fu movie from the 70s… Hey 'Little Scarab,' how's it hanging?" barked Charlie, who had just entered the restaurant, followed by his master.

"Ladies and Gentlemen, I'd like to introduce you to Peter Hack, my computer whiz friend. Without him, we couldn't have opened the restaurant today, as we needed a computer to manage the register."

"And his friendly Bearded Collie, Charlie, with his dapper red bandana," added Marianne.

"The mistress is as hot as her dog," replied the Collie Sheepdog, flattered.

"I thought the Chinese still worked with abacuses," Max Lose whispered to Eddy, who elbowed him discreetly in the stomach to shut him up.

"Friends, let us eat together at the table of honor. Allow your humble hosts to treat you so as to bring happiness and eternal good

luck to this modest restaurant. I'll serve bowls of fried rice on the terrace for our four-footed friends," announced Mr. Wong joyfully.

Max was ecstatic at the idea of a free dinner, even though he had planned to have Eddy pay for him. This way he could eat to his heart's desire. He was already devouring the menu with his greedy eyes, learning by heart all the numbers that he could order. Egg rolls: number 10, Peking duck: number 22, sweet and sour pork: number 36, garlic shrimp: number 19…

As soon as the Wongs' guests were seated around a large round table, and while the four dogs were wolfing down their fried rice, Max started frenetically typing away on the keyboard of his iPhone.

"Can't you turn that thing off for just a few minutes?" asked Eddy. "Just so we can eat our dinner in peace?"

"Show business is never in peace, man," he answered. "Hollywood is war! *Holly war!* And, don't worry, this is about you."

"You know, Max, sometimes your little secrets scare me."

"The evening's not over yet, Eddy. And I have a huge surprise for you…"

The bowls of fried rice were long licked clean and the four gourmet dogs, their bellies full, were talking on the terrace in the warm L.A. summer night. Suntzu and Charlie, who at first considered the Dalmatian accompanying Barbarella as a rival, now bombarded him with questions about his dog's life in Malibu. Although slightly jealous of the close relationship between the two Dalmatians at first, they soon welcomed the friendly Californian dog with open paws. After all, their new friend seemed to have chosen him as her mate. Delighted to have made such a wonderful pal in the plane, they consoled each other by saying that there was surely no shortage of beautiful females in Los Angeles.

"The wise Shar Pei must not resist when the Dalmatian has chosen a companion of her own race," murmured Suntzu in Charlie's drooping ear. "If she was not genetically attracted to his common Croatian origins and his similar spots, Barbarella would have easily succumbed to the spicy charm of Asia and my irresistible wrinkles. Thus, you will not be offended by seeing me seduce her right under your beard, my Collie."

"Whatever, you sack of lumps!" retorted the Bearded Collie. "If the black and white charmer hadn't been here, she would have followed the sheepdog like a nice little lamb. You're the Croatian!"

"Croatian is not an insult, my friend, you who are limited by too much time spent watching sheep. Croatia is a Southern European country. Dalmatia, where our spotted friends originally hail from, is a southern region of this country bordering the Adriatic Sea..."

"Enough, Suntzu! I've had it with you..."

He suddenly stopped short and, along with his three friends, turned towards the restaurant, which was buzzing with activity.

Inside, accompanied by two bodyguards and her temporarily inseparable assistant Alberto V, a handful of noisy friends and a horde of paparazzi, Jenny Palace had just made her appearance. As noisily as ever. For the occasion, the fashion victim had slipped into a short pink Chinese tunic that barely reached the top of her thighs. She was perched on matching thigh-high boots with ridiculously high heels. For the final detail, her hair was tied up in a bun, held together with two chopsticks. It goes without saying that poor Gucci, gripped in her hand, was stuffed into a small coat in the same pink print as that of his mistress's dress. The customers in the restaurant were hypnotized. They had stopped eating and some were starting to pull out their cell phones to take pictures of the starlet.

"When Max texted me that you were eating in this new restaurant, I just couldn't resist coming to see my new friends," Jenny said as she reached the table of Mr. Wong's guests.

"Thanks for the surprise, Max. I'll get you for this, you traitor," mumbled Eddy, while Marianne's face dropped.

"Well excuse me for thinking about your career! This girl is crazy about you. Anyone can see that! I'll be able to send your screenplays to her tomorrow."

"But who's that on the terrace? You came with your adorable Dalmatians!"

"And what are we? Dog food?" grumbled Charlie. "Who does that pink airhead think she is? I'll teach her..."

Charlie didn't have time to finish his sentence. Two men dressed in black and hooded like ninja warriors had just burst into The Pagoda. Threatening and armed with machine guns, they met with no resistance from the bodyguards, who raised their arms in submission.

"We came to kidnap the young billionaire," the ninja leader calmly stated, after grabbing Jenny Palace. Gucci, shaking more than ever, managed to jump from his mistress's arms and hide behind a big statue of Buddha. "Stay where you are and no one gets hurt. If you make one move, it's bye-bye blondie!" he added, sticking the barrel of his gun against Jenny's head.

They backed out of the restaurant near the stairs and then disappeared with their hostage, while the powerless witnesses watched in fright. Suddenly, listening only to his courage and intent on saving a woman in danger as he had done a few hours earlier, Bogart rushed towards the exit and disappeared in turn before his four-footed comrades had time to react. The door was already closing on the paparazzi, furious that they couldn't photograph the rest, but not brave enough to try to defy the armed kidnappers.

In the now-silent room, they could hear sounds of struggling from outside. Growling and barking, followed by a muffled yelp from Bogart. Then, nothing. Total silence. Eddy ran to the door and pulled it open only to see Jenny Palace, her hair a mess. She was alone.

"Your Dalmatian saved me, Eddy!" she cried, throwing herself in his arms. "Without him, those **** lowlife punks would have taken me with them to do who knows what to me. But, I'm afraid they took their revenge on poor Bogart and carried him off. Sniff. He acted like a real hero! I'm so sorry. It's so awful. Sniff, sniff."

"Bogart! My best friend. No. It's not possible. Not him, not this," said Eddy, crushed, before falling onto his knees.

12/ Jenny Palace's home. Beverly Hills.

The failed kidnapping of Jenny Palace monopolized the headlines of all the media, not only in Los Angeles, but all over the world. There wasn't one daily, one magazine, one news program, radio show or website that didn't talk about the freak occurrence that managed to overshadow the biggest problems on the international scene. In addition to the paparazzi photos, a video filmed on the mobile phone of a customer at the restaurant, who witnessed the entire scene, was soon played over and over on the web before being re-aired on every TV station in the world. It was almost as if global warming had suddenly become an anecdote next to the kidnapping attempt of the billionaire starlet.

This time, there was no doubt about it. The glory-seeking young woman had hit the bull's-eye. Her name was now officially the most googled name on the planet, earning her another place in *The Book of World Records*. And, lending truth to the adage that you should only lend to the rich, Jenny Palace stocks (the first time an actual human had dared to be listed on the international stock market) had skyrocketed on all the international finance markets. The very next day, Jenny Palace products met with astounding sales. Albums, videos, books, dolls, handbags, clothing, fragrance, underwear, makeup, shoes, you name it. Everything that had Jenny Palace's name or face was cleaned out of stores worldwide.

Seated behind her big desk, her feet propped up on a pile of newspapers and celebrity magazines, the young woman was in seventh heaven. Her fortune, already colossal from the moment of her birth, continued to rise, on par with her fame.

"Do you know what that genius Dandy Warhol said?" she asked Alberto V, who was unenthusiastically cutting out the latest press clippings about his boss and gluing them in impressive albums, already numbered up to 3,659.

"His name was Andy, *Bellissima*. Andy Warhol, not Dandy," answered her assistant, rolling his eyes.

"I already warned you not to interrupt me. You stupid insolent ignoramus. Do you think I'm uncultured or something? I'm talking about the old guy with the yellow wig who created the Muppet Underground and who made all that Popcorn Art with his trendy, edgy friends ages ago, last century, in New York. Well, he said something very wise that mommy used to repeat to me all the time when I was little. Something like: 'In the future, everyone will have their 15 minutes of fame.' Well you know what? Mommy always added that only a loser would say that. And that for her little Jenny, she didn't want 15 minutes to go by *without* her being famous. She was right. Don't you see? Mrs. Kathy Palace was light years ahead of Dandy Warhol! My mommy was the ideal *Pitta*!"

"Pita? Like the Greek bread?"

"No, you dimwit. The girl who predicted impossible things that actually came true. Of course, you wouldn't know about that because this was in ancient times when the Greeks were ruled by Cleopatra. Instead of cutting them out, you should *read* magazines from time to time, Alberto. You know, these things with lots of words inside next to the photos," she added, throwing him the latest issue of *People* magazine, with her picture splashed on the cover. "It's by reading interviews with really smart people like me, Carmen, Pamela, Lindsay – no, not Lindsay – and Nicole that you can actually become smart too. You're not born a billionaire by chance, poor little Alberto. It's a conjunction of the stars, karma, genes and intelligence. And then, it's your class that makes all the difference. It's like being a celebrity: it's a full-time job."

Jenny Palace's lesson on the meaning of life and the history of art and antiquity was stopped short by the ringing of her mobile phone. The ringtone was the first refrain from her song "Call me if you want to have fun." With a wave of her hand, she motioned to her assistant to go do his kindergarten cut-outs somewhere else. In other words, to take a long boat ride on the Nile (where the Greeks live).

"Miss Palace?"

"Who else would it be? You think you dialed 911? Hello, you have reached 911," she said, imitating an operator's voice. "Please don't die yet. We'll take your call in a few hours."

"It's Tony."

"I know. Your name popped up on the screen along with a picture of a skull and crossbones."

"The men I sent you told me that they were able to capture the last Dalmatian that we needed," continued Tony Pinofarino, while Gucci, pretending to sleep in his basket, raised his long tapered ears so as not to miss one syllable of the conversation.

"Luckily I didn't wait for you to get everything in place. If I hadn't been lucky enough to meet those people on the beach with their Dalmatians and if I didn't have the extremely clever idea of this bogus kidnapping, you'd still be wondering how the hell you'd finish everything in time."

"All the same, you're going to have to pay a little more for my guys. The dog is a fighter. He bit them savagely before they put him to sleep with chloroform."

"It's not my problem if your assistants are wusses, Tony. I'll give them a little something once the Dalmatian has landed safely on the island, ready to be used for the cover of the steering wheel and gearshift of my future car. By the way, did my birthday present arrive?"

"The Bentloyce is already there. We're just waiting for the last Dalmatian to start the operation. The 3D models of your future car are already done. I sent them to you by e-mail. You'll see, the Dalmatian-skin Bentloyce is going to rock. As for the dog, we hid him in a cage in the private hangar of your plane, which is ready to take off the day after tomorrow from the Santa Monica Airport, Miss Palace."

"I know," she said. "I called the pilot of the Jenny Jet to tell him that I would be on the plane. I'll arrive on the island in two days with you and the dog," she concluded, before hanging up.

"Why are staring at me with your Tori Spelling eyes? Don't worry, Gucci, you're coming too," she told her four-footed whipping dog.

Then, she gleefully looked through her e-mail to find the virtual images of her future car, entirely covered in Dalmatian skin.

13/ Malibu. Eddy and Bogart's apartment.

The day was almost at an end and they still didn't have any news about the Dalmatian kidnapped the evening before by Jenny Palace's attackers. Eddy was heartbroken. First, he thought that Bogart's captors would abandon him during their getaway after leaving the Wongs' restaurant. But, unfortunately, despite the many police cars patrolling Chinatown in search of clues leading to the bandits, the LAPD detectives couldn't find a trail. The agents couldn't get one serious witness statement or any information about the kidnapped dog. Eddy had to face up to it: the thieves and their prize seemed to have vanished into thin air. And the forces of order were hardly concerned about a missing dog.

"It's clear that the gangsters wanted to get some huge reward from Jenny Palace's incredibly rich family by kidnapping the young woman," summed up the inspector in charge of the investigation. "As their plan was cut short by your brave dog, I think they probably took out their anger on him. I'm sorry," he added, putting his hand on Eddy's shoulder, "but there's little chance that your Dalmatian is still alive. I can assure you that the LAPD will do everything it can to find and punish the criminals. You can be proud of your pet. He was a real hero."

"Pet?!"

The inspector's choice of words was, at the very least, insensitive. Bogart was much more than a pet for Eddy. Bogart wasn't just a Frisbee partner, a surfing buddy and an aficionado of his spaghetti carbonara. Above all, for the past two years, his Dalmatian had been his best friend, his confidant and his accomplice. His spotted

double. His black-and-white four-footed brother. Himself in the form of a dog. Obviously, the policeman had never had a "pet" in his life.

United around Eddy since early in the morning, Marianne, Peter Hack, the Wongs and even Max Lose, who didn't have a dog but who claimed to be Bogart's loving godfather, understood and shared their friend's pain. Marianne, who had stayed at Eddy's place since her arrival in L.A., hadn't slept a wink all night. She tried to reassure him that things might turn out okay. Several times, she slipped off to the kitchen to cry in private, pretending that she was going to get a glass of water.

The long sighs, sometimes replaced with yips from her Dalmatian, filled the young author's apartment with sadness. An apartment so cheerful just a day before. Barbarella lay prostrate on the terrace in the same spot where Bogart had spent hours watching the Malibu waves, in order to stay in contact with the smell of this Dalmatian male who had won her heart. With her hundreds of millions of sensory receptors, Barbarella couldn't stop sniffing the olfactory marks left by her loved one or admiring the smallest black or white hair left on the teak terrace.

"We can keep posting flyers with Bogart's photo all over Los Angeles," suggested Max. "After all, even with several of us, one day wasn't enough to cover every spot in the city. And if that doesn't do it, we'll go post our flyers in San Francisco, Santa Barbara, San Diego… Everywhere in California. I'm even ready to go all the way to Mexico if I have to. I'll do anything to get my godson back, Eddy."

"As for me, I'm going to keep flooding the web with search notices for Bogart. No e-mail account in the United States will be spared, believe me," added Peter Hack. "And not one firewall will stop my pop-ups from showing up on all the websites and e-mail accounts consulted by every American citizen. Including those of the FBI, NSA and CIA!"

"We told the entire Asian community of Los Angeles to look out for Bogart," concluded Ping Wong. "If there's a trail, we'll find it. The grapevine is nothing compared to the 'Chinese connection'."

"You are all so nice, but you've done more than enough today. You should go home and rest. Lisa and Ping, you have a new restaurant to run. Peter, you need to launch your website. And Marianne, you didn't come to Los Angeles to walk up and down the

streets in search of a lost dog. You came to learn how to be an agent to the stars with my old friend Max."

"Well," responded the Frenchwoman, "if it's okay with Max, I'm going to start my training by becoming Bogart's agent. You may have noticed that the media are only talking about that b... (she stopped herself just in time from saying something rude)... I mean, about Jenny Palace. They barely mention Bogart's courageous role, although he's the one who saved her."

"That's true," admitted Max. "But we're in L.A., Marianne! You have to be rich and famous to get the media's attention. And Bogart isn't Zac Efron. Or even Scooby Doo."

"Well, I don't know if Bogart will be rich some day, but I can guarantee that, soon, he'll be more famous than Harry Potter! I'm going to turn the journalists' attention to Bogart. And his kidnappers will be so scared to get caught that they'll have to let him go."

"Maybe, if my poor Boogie is even alive," Eddy declared sadly and fatalistically.

"You *must* believe it, Eddy," Marianne shot back. "I'm sure that Bogart is waiting for his beloved master somewhere. What do you think, Barbarella?" she asked her dog, who stood up on her two hind legs to give Eddy a big lick on the cheek, showing the first sign of joy all day long. "You see, Barbie doesn't believe for one minute that Bogart isn't... alive." Eddy broke out into a small smile as he petted the dog.

"That's a tremendous idea, Marianne! Yes, yes, yes!" cried Max Lose, tapping his feet. Because of his "slight extra weight," this had the effect of shaking the whole room. "Eddy, I knew I was right to bring this girl over from France. Not only is she hot, she's also brilliant! Here, Marianne. Use my laptop. You'll find all the numbers of everyone in Los Angeles who's a journalist, writer or media hound and all the jackals on the lookout for a scoop."

"If I have to stay up all night, I swear that by tomorrow, the kidnapping of the bravest Dalmatian in Los Angeles will have stolen the place of Jenny Palace's simpering in all the papers. Then, the police will simply have to start to seriously look for Bogart. Unless the thieves release him before then, of course."

14/ Malibu. Eddy and Bogart's apartment.

Eddy's spirits had hit a new low. Despite all the kind words from his friends, the young screenwriter seemed to be overwhelmed with despair at never finding his favorite Dalmatian ever again. But what words, as positive as they might be, could have eased the anguish of never seeing his four-footed friend once more? Marianne understood. If Barbarella had disappeared, she... Well, she would have been incapable of knowing what state she'd be in. She would certainly be a mess. And, although she hadn't known Bogart for long, she felt as if her own dog was gone.

The young Frenchwoman had to admit it. Despite their very recent meeting, she was already attached to the author who had so generously taken her and her canine friend in. In fact, "attached" was probably too weak of a word to describe her feelings towards her new Californian friend. Because she did have feelings for him. Even though she wouldn't let herself think about this today. It was too early. Too crazy. And definitely not the right time. Yet, she couldn't help asking herself certain questions. Eddy was American and she was French. In two months, her internship with Max would be over and she'd have to go back to Paris, back to her life and her friends. She'd have to find a job in the movie industry there. Did Eddy feel the same way about her? She couldn't bet on it. How could a European student, known to nobody, rival these rich, beautiful and famous Hollywood bombshells like Jenny Palace?

Since Bogart's disappearance, there was no point in even considering it. Eddy was too worried to think about anything apart from his Dalmatian. He even refused to go with her to buy the papers.

He simply lent her his car keys so that she could go to the first newsstand that she could find. He barely rose out of his depression when Marianne showed him the buzz around Bogart's kidnapping that she had managed to generate on the web after spending all evening contacting the key journalists in L.A.

The amateur film showing the Dalmatian's courageous intervention, shot with the mobile phone of a customer at The Pagoda, was constantly being played on You Tube and on all the blogs of the planet, not to mention its presence on Facebook and Twitter. And the papers that she brought back with her, along with some food for lunch, were also starting to delve into the disappearance of the Dalmatian who saved Jenny Palace at the risk of his own life. There was no doubt that all this talk about Bogart would make it easier to find him. A witness would make a declaration in L.A. or somewhere else that would put them on the right track. So as Marianne walked up the stairs of the small building in Malibu, with Barbarella trotting gracefully at her side, she was filled with hope.

But the dog stopped short before even catching a glimpse of the piece of pink fabric in front of the door to Eddy's apartment. Her heightened sense of smell had already recognized the scent. Barbarella rushed to the pink satin eye mask, embroidered with the words: "Get the hell away from here and let me sleep." The dog would have identified it amongst thousands of others. A mixture of the unbearable Jenny Palace's skin, the cause of all their present problems, and her perfume "I, Me, Jenny." A sugary, heady and sickly sweet fragrance, just like its "designer," thought the Dalmatian, who was not the biggest fan of the billionaire starlet. This was mixed with other smells. One in particular, which she identified in an instant. Convinced that the mask wasn't there by chance, Barbarella immediately picked it up in her mouth.

"What did you dig up this time, Barbie? I already told you that a well-trained dog does not pick up everything that's lying around on the ground," Marianne gently scolded her. But she wasn't taking into account the stubborn character for which Dalmatians are known. When these dogs wanted to tell you something, they didn't give up quickly. And the Dalmatian was so sure that she was onto something that she couldn't obey her mistress. So, Barbarella stood up on her two

hind legs to give her mistress the eye mask, which she held in her mouth.

"What am I supposed to do with this pink thing? Can't you see my hands are full with the newspapers and groceries? Come on, throw that away and help me open the door instead."

Half-obeying her, Barbarella stood up again and cleverly turned the doorknob open with her front paws. But she wouldn't let go of her precious clue. If her mistress wasn't able to follow this trail, then Barbarella would find help somewhere else from others who would understand in one sniff that an eye mask left on a porch didn't just drop out of the sky.

"That was quick," Eddy said sadly by way of a welcome. Slumped on the sofa in front of the TV, he was a sad sight to see. The Dalmatian's heart went out to this friendly human who was wallowing in sorrow. And she was sure Marianne felt the same. According to her excellent Dal memory, her mistress had never been this interested in one of her male acquaintances, despite the many two-footed suitors that flocked around her. Men who often tried to win the dog's heart in order to seduce her mistress.

"It's wonderful, Eddy. Now all the newspapers and magazines in L.A. are talking about the brave feats and kidnapping of Bogart. With his photo in all the press and on Internet, I'm sure that witnesses will end up coming forward sooner or later," Marianne encouraged him, her voice full of hope.

"If it isn't already too late…" Bogart's master pronounced.

"Eddy, you have to trust him. Bogart's too smart not to come back. And he's so great and so wonderful that I'm positive that people will get together to help him, thanks to the help of the media."

"Maybe you're right. Plus, Jenny Palace just announced on TV that she's offering a two million dollar reward to the person who finds her 'black and white hero,' as she calls Bogart. We were wrong about her, Marianne. She has a big heart," added Eddy.

"Yeah, a heart of fine stone," grumbled the Frenchwoman, as her dog looked on in agreement.

"I know that you don't like her very much, Marianne, but it's not her fault that my poor Boogie was snatched away. As always, my Dalmatian listened only to his courage. Poor Jenny didn't ask to be assaulted and kidnapped."

Marianne wanted to say that Jenny Palace was anything but poor, but she let it drop. She couldn't let the fact that she detested the billionaire cloud her judgment.

"I stopped and bought lots of delicious things for lunch. If we want to find Bogart, we have to keep our strength up," she changed the subject. "I'll start making…"

But Marianne didn't have time to finish her sentence. Taking advantage of the still-open front door, Barbarella raced out at lightning speed. Marianne couldn't be sure, because it all happened so fast, but it seemed to her that Barbarella was still holding the strange pink fabric in her mouth when she zipped through the living room at the speed of light before galloping down the stairs and disappearing on Malibu Beach.

Now, both Dalmatians were gone.

15/ Private airport in Santa Monica. Hangar of the Jenny Jet.

The Dalmatian's famous stubbornness was finally paying off. The thick ropes wrapped tightly around the opening mechanism of the cage in which Bogart had been held prisoner for so long were about to give way. The dog's sharp teeth got the best of them. Once the rope was gone, it would be puppy's play for the clever and agile Dalmatian to open the cage.

Of course, in the limited mindset of humans, the opening system was designed to be released from the outside by a human hand. But this didn't take into account the Dalmatian's exceptional adroitness. It didn't take long for Bogart to figure out how simple the mechanism was. He just had to slip his two paws outside of the cage's bars and grasp the opening catch. That would do the trick. It went without saying that the cage designers hadn't imagined that a dog would be able to use its brain.

This might be the downfall of humans one day. This constant belief that they were superior to animals. At the same time, this vulnerability was also what made their two-footed friends so touching. Despite their limited sensory receptors, these humans thought they knew everything.

Just a few more nips and the rope would break apart.

"Now for my freedom and time to curl up with my master," thought Bogart. "My dear Eddy must be worried to death." He also started thinking about Barbarella, which gave him a new burst of energy to finish off the rope.

Bogart had to admit it. For the first time in his dog's life, after meeting the beautiful French Dalmatian, he thought he was ready to

start a family. What could be more amazing than to live the rest of his life with Barbarella and the litter that she would give him one day. He could already picture the six or so puppies with their hints of sheer spots and their round bellies cuddling up between them. But his happy thoughts were chased away by the return of his jailers in the hangar. He decided to put his escape on hold. He lay down on his side with his eyes closed and pretended to be asleep, although his every sense was on alert. With his ears on the ready, Bogart wouldn't miss one word of their conversation.

"I won't be sad to get rid of this bag of bones soon," said the first kidnapper, named Alan. He was a red-faced brute with hair dyed canary yellow. His breath reeked of alcohol, bothering the Dalmatian's delicate nose. "Can you believe it? The doctor had to give me ten stitches on the forearm. That's how bad this mutt bit me. We're paid to be artists, not kidnappers of freakin' mad dogs!"

"You got it easy," said the other man. He was a big guy and the name embroidered on his mechanic's coveralls said Brice Ohno. "My doctor had to sew up my butt! I'll probably have a dog bite permanently etched into my behind for the rest of my doggone life."

"Good thing he didn't bite into your fat burrito-stuffed belly. That would not have been pretty! Just a few inches over and you would have had an exploding enchilada on your hands, Brice. Brice Ohno and his exploding enchilada!" he laughed, his face lobster-red.

"Very funny, Alan. I'm laughing my butt off. Seriously, you're the most ignorant guy I've ever met in my whole stupid life. Still, as usual, Tony forgot to warn us that working for a young billionaire can be very risky. I'm wondering if it wasn't easier doing the custom work on the king-size limousine of that gangster Armando Noriego than this damn Dalmatian-skin Bentley."

"Easier?! Did you forget that we both lost a finger doing that?" Alan shot back, flashing his left hand, which was missing the pinky. "I get goose bumps just thinking about that guy."

"Yeah, you got that right. A finger cut off for each day his limousine order was delayed is a high price to pay. That Noriego wasn't exactly the nicest guy in the world," agreed Brice Ohno, showing his own hand, also missing the same finger. "We had to work hand and foot for him."

"Hand more than foot!"

"And thank god the boss stepped in to save two more fingers, because don't forget we finished the car three days late. You know, instead of looking like Japanese mafia morons – you know the ones who get their little finger cut off by their boss when they mess up a job, what are they called again? Jacuzzis?"

"Yakuzas. They're called Yakuzas, Alan."

"Yeah, well instead of looking like those freakin' lemonheads with their cut-off fingers, if we had three fingers missing instead, we would have looked like surfers," he commented, making a "hang ten" sign with his full-fingered hand.

"And yet again, it's up to us to do the dirty work and deal with the problems. Last time, the boss may have saved two of our fingers, like you said, but don't forget that Tony has both his hands intact. And this time, he's not the one cringing in pain every time he tries to sit down. Just the idea of sitting down in this freakin' plane makes me sick as a dog."

"Speaking of sick dogs, don't worry, man. Soon we'll get our revenge for these bites. Don't forget that 186 friends of this two-toned freak are obediently awaiting his arrival at the island to be tenderly stripped of their skin in order to decorate the famous Jenny Palace's birthday present. Remember: it's a dog eat dog world, pal!"

"You're right. And the joke is on the Dalmatians!"

As they left the hangar, the two slimebags broke out into stupid, evil laughter that made Bogart's hairs stand on end. Now, Bogart understood the horrible plan that was meant for him. And he finally discovered the person who was behind it all. The very woman whom he thought he was saving from a terrible kidnapping, after believing that he had saved her from drowning at Malibu Beach. Jenny Palace had set a Machiavellian trap for him, but he was only a couple of bites away from getting free. He automatically started attacking the rope again. Alone now, he had ample time to get out of his cage and slip away from his dognappers to return to his dear master and beautiful Barbarella. But he had heard too much.

If he left now, no one else could help the 186 other Dalmatians kidnapped to appease the whims of the billionaire. He forced himself not to think about returning to Eddy, Barbarella and her mistress, the kind Frenchwoman, and suddenly stopped biting the rope, which only needed a few more nibbles to give way completely. There was no way

that Bogart would spare his skin without trying to save his companions from a hopeless future.

He gave his word as a Dalmatian. He had made up his mind. Bogart would let himself be taken to this mysterious island mentioned by the horrid humans and he would do everything he could to save his black and white friends. All the same, the Dalmatian whimpered when he thought about the pain and anguish that his beloved master must be going through because of his disappearance.

16/ The Pagoda restaurant. Chinatown.

Barbarella wasn't too tired when she finally arrived at the restaurant of Suntzu's owners. With its almost 802 square miles, Los Angeles was a vast city. And Chinatown, the Asian neighborhood in the northeastern region, was quite far from Malibu Beach. In order not to wear herself out completely, when she left Eddy's apartment, Barbarella had leaped into the back of several pick-ups until she reached her final destination. So her paws weren't too sore from the hot asphalt of the L.A. sidewalks.

She arrived between lunch and dinner and the restaurant was dark and empty.

"To what do we owe the honor of your graceful and celestial presence, oh noble Dalmatian of Croatian ancestry?" resounded a mysterious voice in the darkness.

"Shut up, Suntzu!" barked Charlie. "You are really starting to bust my chops with this cheap zen master talk. Stop pretending that you're Yoda, you bag of wrinkles. Hell-o! Earth calling! You're in America, man! In L.A., not on Dagobah!"

Seeing their guest, the sheepdog continued, "Hi, gorgeous! What a nice surprise. What's up, spotted baby doll? How's it hanging?"

The banter of her two friends whom she had met on the plane made the Dalmatian feel a little more comfortable. The Shar Pei and the Bearded Collie were still the same old mutts, but they were really great. Good dogs with big hearts. She immediately explained why she was there and she had them sniff Jenny Palace's sleeping mask.

"Pee-yoo, that perfume stinks!" exclaimed Charlie. "I recognize the smell of human skin in the background. There's no doubt about it. It belongs to that witch who ruined our dinner."

"I see that your sense of smell has not been hampered by all the hamburgers you eat with your geek master, my friend. This is indeed a mask belonging to the billionaire who almost got kidnapped during the inauguration of the restaurant of my honorable masters."

"The question is: why did I find this thing in front of Bogart and Eddy's apartment this morning?" asked Barbarella.

"Umm, maybe the wind blew it there? I heard that the Santa Ana was blowing hard near Malibu right now. On the news, they announced that there was a risk of wildfires. Maybe the mask flew off the terrace of Jenny Whatsername's mansion in Beverly Hills and landed at Eddy's place," suggested the Bearded Collie, though he didn't sound too convinced.

"Right, Charlie," Suntzu retorted. "Why don't you say that Shar Peis are descended from Siamese cats while you're at it!"

"Okay, wrinkle face! Fine, maybe the wind is a bit far-fetched. But how do you know for sure that your ancestors aren't Siamese cats? That would explain a lot of things…" Charlie started humming the "Siamese cat song" from *Lady and the Tramp*.

"We are Siamese if you please. Pom-pom-pom-pom. We are Siamese if you don't please. Pom-pom-pom-pom. Now we looking over our new do-mi-cile. Pom-pom-pom-pom. If we like we stay for maybe quite a while…"

"Go eat cat chow, you dumb fleabag!"

"We don't have time to mess around, guys. This may be our last chance to find Bogart. He means so much to me. Please help me! Without your sense of smell and your intelligence, I'll never be able to pull it off. You're my only canine friends in Los Angeles."

Seeing their protégée's distress, the two friends stopped joking around. They looked at the Dalmatian tenderly and moved to her side.

"Don't worry, darling. We'll find your handsome Pongo. Give me that mask."

"With her paw, she handed the piece of fabric to Charlie, who sniffed it again.

"I would just like to point out that her perfume is an insult to my nose. But in addition to her human scent, I smell something else…

You already noticed it, right Barbarella? Friends, this mask didn't arrive at Eddy's place by chance. Someone brought it there on purpose to put us Jenny Motel's trail."

"Palace, Charlie. Her name is Jenny Palace," Suntzu corrected him.

"I don't care if her name is Palace, Motel or Best Western - my little claw tells me that this blond brat has her paws mixed up in the dognapping of our Dalmatian buddy. Suntzu, I take it that apart from their abacuses, the Wongs have something that looks like a computer. As soon as we find out the exact address in Beverly Hills on the web, why don't we all go pay a little visit to Miss Jenny Whatchamacallit."

"Do you really believe that a billionaire's address is accessible to just anyone on the Internet, my presumptuous friend?"

"Your Dogfucius must not have taught you the saying 'like master, like dog.' When I was four months old, Peter already taught me how to order my own dog food on the web. Today, I can hack into a NASA program with a few strokes of my paw, wrinkle face."

17/ Jenny Palace's mansion. Beverly Hills.

The sun was setting over the sumptuous properties of Beverly Hills when the three dogs neared the billionaire's mansion. The light was soft. Magnificent. As beautiful as in a TV show, thought Barbarella. A gown of orange-tinged light. A dress that only the city of Los Angeles seemed capable of wearing. Just before arriving in front of the impressive building that looked like Sleeping Beauty's castle from the Disney film, Suntzu stopped in front of a small car parked next to a beach umbrella. Under the umbrella, seated on a deck chair, a young man seemed to be waiting for customers. His presence and his strange set-up stuck out like a sore thumb amongst the billionaires' houses. If a Beverly Hills cop had come by, this strange character would have scuttled off in a second to avoid ending up at the police station. But what caught the Shar Pei's attention was the clumsy writing on a large cardboard sign that said "Star Maps."

"Hey, dogs," said the salesman, who was wearing a Lakers cap and extra-large sunglasses. "Not a lot of tourists around today. Do you want to buy my map of the stars' homes? Just five dollars. It's the latest edition. You'll find all the addresses of the stars who live in L.A., from Britney Spears to Brad and Angelina by way of Jenny Palace, right behind me. Come on, doggies, be nice. I'll trade you one for a bone," joked the salesman, thinking that he was talking to himself. "Wow, look at that Dalmatian. Does the pink B you're wearing around your neck stand for Beverly Hills?" he laughed, while the dogs were trying to figure out how they would get into the property.

"When I think that we lost half an hour in front of a stupid screen breaking who knows how many federal laws to get an address that all these street map vendors offer everywhere..." Suntzu grumbled, looking at Charlie. "And we needed a computer whiz Bearded Collie able to hack into NASA programs to get this information!"

"Sorry, but did you have five dollars, smartypants?" responded Charlie.

"Hey," interrupted the Dalmatian. "Instead of snapping at each other, you should try to find a way of getting into this property, which is chock-full of security systems."

"Don't worry. My electronic skills will help us get past all the alarms. Which goes to show that it's good to have a nerdy dog with you who's able to sneak into a military base, right, wrinkle face?"

"Just as good as having a dog trained in martial arts and ninja techniques who can slip between the infrared cameras, as lithe as a c..." Suntzu stopped short, before he could say something that would come back to bite him on the rump. But the Bearded Collie's mind was on overdrive.

"You see! You said it yourself! Your ancestors were Siamese cats!"

"That is incorrect. I certainly did not say that."

"Oh, yes you did! You said it! You said it!"

"That's enough, you two. You're going to draw attention to us."

"But that's what he said. *'We are Siamese if you please... pom-pom-pom-pom'*."

"Hey, Bill Gates!"

"Yes, Catfucius?"

"Shut it."

The four-footed brainiacs soon found a way to get over the wall without setting off the surveillance systems. It was also puppy's play for them to slink between the infrared cameras, which were really designed to detect the presence of humans, not animals. Their luck held out: Jenny Palace's security agents didn't seem to have any dogs with them. If that had been the case, the three friends would have been identified by their smell alone by Doberman or German Shepherd watchdogs. Fortunately, nature still hadn't endowed humans with the sharp senses that dogs possessed.

Once they made it inside the immense mansion, they didn't have any problem finding out where the owner was. The smell of her skin, intertwined with that of her perfume, seemed to come from the upper floor. Just like that third smell. The one that the three dogs had also identified on the night mask.

Once inside the enormous lounge where the starlet was, the three dogs exchanged quick glances and agreed to hide behind the humongous pink velvet drapes, embroidered with the initials "J.P." The only problem was that, in addition to the billionaire's assistant, her Chihuahua was also in the room.

Despite their sneaky entrance, worthy of a canine team from *Mission Impossible*, any dog could easily detect their presence with one whiff. Even so, the three dogs padded silently and calmly towards their hiding place. They all knew that Gucci, who had certainly detected their presence on the property as soon as they had entered, wouldn't growl or bark to warn his mistress. The Chihuahua wouldn't make a sound simply because he was the mysterious informer who had left Jenny Palace's night mask in front of Eddy's apartment. The third scent on the mask was that of the Chihuahua.

Perfectly hidden behind the draperies, the three dogs now listened closely to the conversation in Jenny Palace's lounge. Come what may, they had to glean some information that could take them to the place where Bogart was being held captive. Because, according to their infallible sense of smell, there was no doubt in their minds that the billionaire was responsible for the Dalmatian's dognapping. What the three sleuths wanted to know now was why she had kidnapped him and where she had taken him.

"*Bellissima*, wot an excellent idea to have prrrromised a rrreward of two million dollars to the person who finds the leetle Dalmatian who-a saved your *vita*. How *génerosso* of you," cooed Alberto V, while he applied fuchsia pink nail polish to poor Gucci's claws.

"One thing's for sure. *You* wouldn't have lifted a finger to try and stop me from being kidnapped."

The assistant looked away with a hangdog look, pretending to concentrate on the manicure.

"Think long and hard about that, Alberto. You have to know how to be generous and do good in this often cruel world," continued

Jenny Palace with unhidden hypocrisy, her voice quivering dramatically.

"*Bravissimo*! Deep down, I always knew that-a…"

"*That-a* what, you wannabe macaroni numbskull?"

"That-a you were not so…" he pressed on, shaking. Without realizing it, he was continuing to apply the nail polish, which was now painted on the hair of the poor Chihuahua, who was also trembling.

"*So*…? Explain yourself. Don't be afraid."

"So cru…"

"Crude?"

"Umm… almost. You're getting warm…"

"I got it. Cruel! Bingo, Alberto! You're saying that you didn't think I was so 'cruel.' That's what you were saying, Alberto."

"That's the gist of it." (When Jenny made him nervous, he forgot his Italian accent.)

"Well, my idiotic future ex-assistant, I'm still as cruel as ever, if you want to know the truth. Maybe even a little crueler each day. Being nice is for wusses. And I hate wusses. Just as much as I hate poor people. Gross! Poor people are so… poor! It's pathetic. Don't go thinking that I offered this reward out of the goodness of my heart. Something tells me that I won't have to pay out the two million, because no one will ever find that stupid mutt who thinks he's some kind of Superdog. My declaration in the media just brought me more respect and made my stock rise even higher. Charity is a business, just like show business. If you want to make it in L.A., never forget that."

The ringtone of Jenny's mobile phone started blaring around the room. For this caller, she had replaced the personalized ringtone the night before. Instead of the song from her album, "Call me if you want to have fun," the phone now rang with the theme song of the show *My Super Sweet 16*. A reality TV show on MTV in which parents, as mindless as they are rich, spend fortunes organizing sumptuous and indecent parties for their atrociously materialistic children's 16th birthdays. This ringtone was specially chosen in honor of her upcoming party and her present, which Pinofarino would customize to celebrate her 26th birthday. The Dalmatian-skin Bentloyce. After a few seconds, with the skull and crossbones also flashing on the screen, she motioned for Alberto to scram.

"The lesson's over," Jenny announced. "Now leave me alone, Alberto. And go clean Gucci's hair. Look what you did to this turd-on-legs. Don't you think he's ridiculous enough already? How funny. It looks like you painted pink thigh-highs on him." And she broke out into high-pitched laughter. "He looks like... He looks like Lady Gaga!" she squealed, proud of her joke and laughing even harder. She wiped away her last tears of laughter as she took the call. Then she pulled herself together.

"Tony, what's up?" she answered, as serious now as if she were Jack Bauer answering a call from Tony Almeida in *24*.

"The pilot just arrived at the hangar. The flight is scheduled in two hours. We're only waiting for you, Miss Palace."

"And the Dalmatian?"

"No problems there. Brice and Alan check on him from time to time to make sure he's not trying to get away, but the dog has stayed obediently stretched out in his cage. After he bit them, they gave him a sedative to prolong the effects of the chloroform. Since he woke up, he seems to have accepted the situation. He's not even barking. He's as gentle as a lamb being taken to slaughter," he added, laughing.

"Perfect. I'll have the maids pack my suitcases and I'll meet you in Santa Monica in one hour."

18/ Santa Monica Airport. Los Angeles.

The three friends didn't stay at Jenny Palace's sumptuous home any longer than they had to. Once they got the information they needed, they zipped over to the Santa Monica airport by discreetly hitching rides in the backs of pick-ups. Of course, it would have been easier to just wait for the starlet to leave and slip into the trunk of her long limousine. Despite the impressive number of suitcases that the billionaire planned to take with her, they could have hidden themselves behind all the luggage. But they would have wasted precious time and there was too high a risk of getting caught.

Once they reached the airport, it didn't take them long to pick up Bogart's trail. Although humans, with their limited sense of smell, find that Dalmatians don't have a "dog smell," any dog could tell you that Bogart was somewhere in the airport. Once again, it all came down to the number of sensory receptors in their noses. Now all they needed to find out was where he was being held prisoner. Their noses at the ready, Barbarella, Suntzu and Charlie started sniffing the air.

"You'll find your friend in hangar number nine. Straight ahead, left and then left again. You can't miss it. The building is painted candy pink." The deep voice took them by surprise.

The three dogs quickly spun around. Barbarella and Charlie jumped, while Suntzu posed in an attack position worthy of Hong Kong Fu Fu, the justice-seeking martial arts dog. Across from them, an imposing Rottweiler had appeared. They had been so focused on identifying the Dalmatian's smell that they hadn't noticed the scents of the other dogs. Hanging on the Rottweiler's khaki green collar were two military-style dog tags and a photo badge with his name, ID

number and the name of the dog security company that employed him: Black Dog.

"Relax, guys. I'm on your side. My name is Rambo, but my friends call me Sly. And if you find yourself in a hostile situation, don't hesitate to bark for me. You can count on me. I give you my word as a former Marine dog. *Semper fidelis*, guys."

Rambo watched the determined trio set off on the tarmac. "Good luck," he murmured. "Your friend is a good guy. He's brave and courageous. He deserves to be saved. And what a pretty little dog that was!" he thought. "A good-looking thing. She reminds me of Salma, a gorgeous, sexy Afghan Hound I met when I was patrolling the Pakistan border. Ah, memories, memories… Here I am getting nostalgic. Still, it's always the same ones who get lucky…"

The commando Rottweiler was right. With its flashy pink color and the initials "J.P." painted on it in a golden heart, the hangar was difficult to miss. The large sliding doors were open and some mechanics were making last adjustments to the pink jet. The plane would be leaving soon. In all the hustle and bustle before takeoff, Barbarella and her two canine cohorts had no trouble slipping discreetly inside without catching the attention of the men.

Not far from the plane, seated around a table set up on trestles, two of the very worst specimens of humans were playing cards and drinking beers. The fattest one was sitting on an enormous cushion. Near them, by a stack of big cans, they spotted the cage. Bogart, who had sensed the presence of his friends as soon as they got near the airport, was waiting for them, at the ready.

Tiptoeing behind the big cans, the trio soon arrived at Bogart's cage without alerting the two kidnappers. The joyful reunion was limited to tail-wagging. But, not paying attention, Barbarella hit an empty beer can with her tail. It rolled along the ground, rattling as it went.

"Did you hear that, Brice?"

"Don't worry. It must be the mechanics getting the queen bee's plaything ready to go. He must have dropped a wrench," answered the fat man on the cushion, before gulping down some beer noisily. He turned towards the cage and saw Bogart sitting inside, immobile and stoic. Like a porcelain dog. "At any rate, this dirty dog won't be

causing us any more problems. Just look at him. We scared him so bad that he's not even twitching an ear," he sniggered. "You know who's in charge now, right you sharp-fanged vampire!" he yelled at Bogart, as he slid his hand between the cushion and his big bottom, which still smarted from the Dalmatian's bites.

"Leave him alone. In a few hours, it'll be no skin off your back," cackled Alan, making Brice guffaw.

"That's a good one! No skin off my back! Just the skin off his back! Ha, ha ha! You mangy mutt. You won't be able to save your own skin! Ha, ha, ha!"

"And remember, beauty is only skin deep! Hee, hee, hee!"

"Good thing we left his medal on him. It's a B for... Bentloyce! Ho, ho, ho!"

The dogs waited for the despicable humans to get back to their drunken card game before they could start talking.

"I'm so happy to see you," Bogart whispered, trying to control his happy tail so that it wouldn't make too much noise hitting the walls of the cage.

"Oh, my Boogie! I was so scared," Barbarella cried, sticking her nose near the bars of the cage.

"We came to set you free, Mr. Handsome," added Charlie. "But I see that you didn't wait for us to attack the rope. A few more nibbles and you'll be out of this cage."

"Unfortunately, I can't leave."

Bogart's response astounded them.

"It's nothing, my friends," Suntzu piped up. "It's a post-traumatic phenomenon caused by isolation. I had a Shih Tzu friend, a real high-roller who spent his life in the gambling dens of Macao, always accompanied by the most beautiful dogs. Well, get this. For who knows what reason, Mahjong, that's his name, decided to accompany a bonze to a gloomy temple on the borders of Tibet. After two months of white rice and prayers, he didn't want to leave his little haven on the other end of the world. The last I heard, he became a monk and is now called 'Blessed Gong'."

"You don't know anything, Suntzu," the Bearded Collie corrected him. "Our Dalmatian friend is a victim of a well-known syndrome that first came to light several years back in a dog pound in Sweden. Dogs of all races were dragged to this pound and became so

friendly with their guards that they didn't want to leave when they were able to. Since this occurrence, we call it the 'Stockholm Syndrome' in canine psychology. There are a lot of dog sites on the web that talk about it."

"Please don't worry. I haven't lost my head. And I long for only one thing: to be amongst you again (the Dalmatian looked lovingly at Barbarella and his glance was returned with wet eyes) and see my dear master. But if I don't leave on this plane, if I run away with you, then 186 Dalmatians are doomed to a horrible fate. I'm the only one who can save them. I can't abandon them."

"You're not alone, intrepid and valiant friend," declared Suntzu. "In the name of chop suey, we will go with you and help you save those Dalmatians!"

"It might be dangerous. Not all humans are as kind as our masters and these ones are particularly loathsome. I don't want you to risk your lives because of me," said Bogart, looking at Barbarella in particular.

"We won't leave you," confirmed Barbarella, lifting her head stubbornly and reminding him that when a Dalmatian set its mind to something, nothing could get in its way.

"We're with you, Mr. Handsome. Plus, I've always dreamed of flying in a jet like this."

"Fine," Bogart caved in. "When they open the luggage hold to put in my cage and Jenny Palace's luggage, you have to sneak inside without being seen. I'll tell you what I learned about this curious affair during the flight."

"Hey, Sun!" Charlie whispered.
"What, my bearded friend?"
"Your weird friend, what's his name again, Blessed Tongs?"
"Blessed Gong."
"Yeah, the Shih Tzu who became a monk."
"Yes, what about him?"
"About him? Nothing. But do you think his hot girlfriends from Macao are on Facebook?"

19/ Jenny Jet. Somewhere over the Hawaiian Islands.

The flight had lasted a little over five and a half hours when the four dogs felt the plane starting its descent. Closed up in the luggage hold of Jenny Palace's jet, they weren't able to admire the beautiful landscapes that they were flying over and that the other passengers, in the cabin, could appreciate at their leisure from the windows. Islands made of white sand and coconut trees seemed to float on the blue water, a swirl of turquoise, navy and ultramarine, transparent in some places and dappled with sunlight. Located right in the middle of the Pacific Ocean, the billionaire's new hangout was one of the 122 islands that make up the Hawaiian archipelago.

The last acquisition of the filthy rich Palace family, the "little strip of land" that Jenny's parents had decided to give her for her next birthday, still boasted a surface area of almost 13 square miles. Recently constructed, the new playhouse where the billionaire could welcome her friends when she was bored of Los Angeles and her frequent trips to Europe was finally ready for the sumptuous birthday party in two weeks' time. Just enough time for Tony Pinofarino to cover the Bentloyce in the skins of soon-to-be 187 Dalmatians.

"Home sweet home!" cried Jenny, as she looked out onto the new property that her parents had offered her. "Hey, wake up, maggot!" she ordered Alberto V, punching him hard in the side before shaking him like an apple tree.

Awoken from deep sleep, Alberto opened an eye and groaned.

"What ees-a happening?" he moaned.

"The plane is crashing!" she yelled in his ear, which made the assistant jump in his seat.

"How horrrr-ible!" he gasped. "I knew I shouldn't have come. Why did I ever get on this plane?"

"For the money that I pay you every month, Alberto. I know that the reason you follow me around everywhere, just like Gucci, is money. Even though, deep down, you adore me all the same."

"That remains to be seen, you pretentious snob," he murmured to himself, rolling his eyes.

"But don't worry," Jenny Palace conceded. "We're simply landing, you coward. I just wanted you to be awake to admire MY ISLAND. You see there, the big building with the pink roof in the middle, with the huge heart-shaped pool with my initials on the bottom? That's my villa. The Jenny Mansion. And over there, between the soccer field (Jenny had a thing for soccer champions) and the football field (Jenny had been a cheerleader in school and didn't mind football champions either), that's the nightclub that can hold up to 500 people, as can the guesthouse, over there. The landing strip where we'll be touching ground soon can hold up to six private jets like this one, as well as a Boeing 747. There's also a pontoon where several yachts can drop anchor. It's so great experiencing real nature, just like Mrs. Robinson," she added sincerely, while in her mind she was thinking of an old song by Simon and Garfunkel that her parents listened to when she was a kid.

"You must-a mean Robinson Crusoe, Friday's friend," corrected the assistant, now fully awake.

"That's enough, Alberto. Not one more word until we land! I want to fully enjoy my arrival at my new property: Jenny Island."

"Poor Gucci," the assistant whispered to the Chihuahua seated beside him. "I'm afraid we won't get much R and R during this island vacation."

Alberto V didn't know the half of it.

20/ Jenny Island Airport. A Hawaiian Island.

"Once you get Miss Palace's luggage out, deal with the dog," Tony Pinofarino ordered his two handymen, Alan and Brice Ohno.

"What are you going to do to the Dalmatian?" asked Alberto when he saw the cage in the luggage hold. He knew nothing about his employer's sinister plans.

"We're going to take him to the garage," replied the unscrupulous custom-car expert for deranged wealthy people.

"The garage?" Alberto asked in surprise.

"If you really need to know, you nosy prick, I need a good guard dog to protect the Bentloyce that I was offered for my birthday," explained Jenny as she got out of the plane.

"That ees-a joke! You are-a afraid of thieves on this island where you and-a your staff are the only people around! How do you-a expect someone to drive into the ocean with your-a car?"

"You can never be too prudent when you're a billionaire, Alberto. And I can't expect that little wimp Gucci to be a guard dog."

"That's strange," added the assistant as he looked at Bogart in his cage. "This Dalmatian looks just like the one who stopped those hooded bandits from kidnapping you."

"Two ears, black spots, a tail. All Dalmatians look alike, Alberto. When I saw the courage of that poor dog who saved me the other day, I knew that Dalmatians would make perfect guard dogs and I bought this one."

"All the same, it's goofy how he looks like that dog," he insisted.

"No, Goofy is Mickey's friend," she sniggered. "He looks more like Pongo!" Alberto was still confused.

Jenny Palace, Alberto V and Gucci took an electric car to the main house, the Jenny Mansion. As this was taking place, Barbarella, Suntzu and Charlie slipped out of the luggage hold while Pinofarino and his two men were busy elsewhere. The three dogs hid behind a slope alongside the runway. According to their plan, as soon as Bogart was taken in his cage to the other 186 Dalmatians being held captive, they would follow him at a distance without catching anyone's attention and while avoiding the many surveillance cameras on the island.

The three dogs had no problem following the electric car that moved slowly on its way with Bogart's cage on it. When they reached the garage, covered with a camouflage net and hidden in an immense coconut tree plantation, they stopped to think about how they would get in. Suddenly they heard the voices of the three atrocious humans, who were leaving the garage. Absorbed by their conversation, the men didn't notice the dogs sneak in behind them. The dogs were finally inside.

"It's almost nighttime," said Tony Pinofarino. "We'll take care of the mutts in the morning. As usual, Brice, you kill them. Alan, you remove their skins."

"Can't we switch for once," asked the fat one. "I'm always the one taking the risks. With the crocodile-skin limo that we sold to the mafia guy, I almost got eaten by a hungry handbag on feet. Not to mention the anaconda who almost swallowed me whole and the snakes that bit me because *someone* promised to deliver a reptile-skin Hummer to a crazy rapper. I had almost eight bites all over my body. Without the anti-venom, I'd be dead as we speak."

"Well you're still here, fatty, that's what matters. So shut your trap. Little Jenny Palace is going to make us very rich, guys," said Pinofarino, before starting up the little car that moved away silently as the sun set over the island.

21/ The Dalmatian's garage-prison. Jenny Island.

"It's as dark as a Doberman's behind," said Charlie.
"Ah, your elegant words will never cease to surprise me, my furry friend," commented Suntzu. "What a poet! You should write a book of poems. You'd be a literary sensation."
"Right, Brainy Smurf. I'll start with a poem about your butt!"
"It gets better and better! How classy!"
"I found the light switch," Barbarella interrupted them.
And then there was light…
"Welcome to the world of Dalmatians, my friends," Bogart welcomed them. He had freed himself from his cage and stood in the enormous garage, suddenly flooded with light. By his side, their eyes all fixed on the three new arrivals, was an impressive horde of black and white dogs. 186 to be precise. In other words, 372 bright, tender eyes staring at them. Almost 200 magnificent Dalmatians of all ages: males, females and puppies.
"Wow! It's like we stepped into a Disney film!" exclaimed the Bearded Collie.
"Except there weren't as many of them," pointed out the Shar Pei.
"Now that we're all united and that we've found your black and white colleagues," Charlie began, "we have to find a way to get the heck out of here."
"For once, my bearded friend is right," nodded Suntzu. "But keep in mind that if we manage to get out of this garage, the worst is yet to come, because we are on an island."

"Well said, Sun! And there's no way we're going to try swimming. Even a Newfoundland would die of exhaustion before catching a glimpse of the next shore."

"Umm, does anyone have a pilot's license?" asked Bogart.

The 189 dogs all looked at each other in silence.

"That's what I thought. Good question, Boogie. Thank you for asking," he continued. "Well, one thing at a time. First, let's find a way of getting out of this morbid garage. Once we're outside, we'll figure out how to get off this island."

"And morbid is right," a Dalmatian named Junior piped up. "Just look what they have in the back."

"Wow, what a car! It's a Bentloyce. I've always dreamed of cruising down Santa Monica in a car like that," said the Bearded Collie, who had eyes only for Jenny Palace's future "toy," which was locked up in a separate workshop, separated by a glass wall. "It rocks!"

"Unfortunately, I don't think that's what our new friend was referring to," remarked Barbarella, gesturing to a sort of industrial system composed of a steel cage from which one of the two doors led to a moving platform connected to an immense aluminum workbench that looked like… an operating table… in a vivisection laboratory.

The four newcomers were horrified to discover the torture instruments methodically organized on each side of the table. A little farther away in the room, their attention was also drawn to two glass containers that looked like giant dryers. It didn't take long for the dogs to realize what this infernal machine was for. Killed in the cage, the Dalmatians would then be stripped of their skin. Then the skin would be dried before being used to cover Jenny Palace's car.

"It's simply…" Bogart began.

"… Monstrous!" Barbarella finished his sentence.

"Actually, I think Bentloyces are a little too bling-bling. I prefer my master's Mini," said Charlie.

"Let's get out of here as soon as we can," Barbarella urged. "This place makes my fur crawl."

"I might be able to help you," squeaked a little voice that sounded nothing like the barks of a Dalmatian, Bearded Collie or Shar Pei. The dog's accent was definitely Mexican. The billionaire's poor

slave-dog Chihuahua had just appeared in the garage. "My name is Gucci," he introduced himself to the canine assembly.

"Friends," announced Barbarella to the 186 Dalmatians. "May I present your guardian angel! Without him, we would never have found Bogart's trail and never arrived here. Thank you, brave Chihuahua," added the Dalmatian and licked the top of the little dog's head. The Chihuahua seemed on the verge of fainting. He went all gooey under Barbarella's charm.

"Don't even think about it, Speedy Gonzalez," said Charlie, bringing him back to reality. "She's crazy about the black and white Mr. Handsome over there. That looker with an athlete's body and a movie star name. Otherwise, she would have fallen paw over heels for me."

"Dogfucius said: 'He who barks higher than his head soon falls down'," the Shar Pei intervened. "Perhaps she would have fallen for the charms of eternal Asia? *One night in Bangkok and the world's your oyster*," he began humming.

"Don't think too hard, wrinkle face. Your brain might explode."

"I'll tell you what's going to explode, you annoying sheepdog."

"You are both magnificent purebreds," Barbarella said to calm them down. "And if I hadn't met my Dalmatian double, I would have been smitten by *your* canine charm and *your* doggish humor."

The two dogs immediately shut up, their faces rapt with the same lost look that Gucci had after he was licked by the Dalmatian.

"Umm, can we get a lick too?" asked Charlie.

"Later, when we're all safe and sound," answered Barbarella. "I promise."

"How did you get in?" Bogart asked the Chihuahua, suppressing a pang of jealousy. The Chihuahua was just getting his wits about him after all the emotion.

"With my island pass," said the little dog, twisting around and grabbing a little remote control case slipped onto his leopard-print fuchsia pink collar. "This magic remote control opens all the doors of Jenny Island. I can get you out of the garage, but unfortunately, I don't know how to fly a plane either," added Gucci, in his Mexican accent.

"Hey dogs, I'm starting to like this taquito-sized chicano," said Charlie.

"It's so brave of you to do this for us," continued Bogart.

"You know, even if Jenny Palace is a little (here, the Chihuahua paused to choose his words carefully), how can I say… *loca*, deranged in the *cabeza*, she is still my mistress. I'm a dog. Like you, I'm incapable of being disloyal. And I know that she loves me, in her own way. And I love her, in my own way. But this time, she has gone too far. I cannot let her hurt my canine *compadres*. *Comprendes*?"

"Yeah, that's quite a dilemma, *amigo*," agreed Charlie, gently patting the little dog's shoulders with his big grey and white paw. "Having to choose between my master and my dog chums… Well, I wouldn't want to be in your fur right now."

"The sage said: 'Betrayal is but another facet of fidelity'," quoted Suntzu, giving the Chihuahua a friendly pat.

"Is that your Dogfucius again?" asked the Bearded Collie.

"No, Plato. A human from ancient times."

"And does your Plato have an idea to get us out of this 'cave'?"

"Come again?" asked Suntzu, surprised at this reference to the Greek philosopher from the sheepdog.

"Hey, wrinkle face, it looks you choked on an egg roll. You know what: it's possible to be furry, Californian, wear a bandana *and* be well educated. Don't forget that I lived with my master on the Berkeley campus before moving to Paris and then L.A."

"I think I have a plan that's worth trying," Bogart interrupted them.

22/ The Dalmatians' garage prison. Jenny Island.

"When you think about it, there's no need to leave right this instant," Bogart explained to the assembly of dogs, who were hanging onto his every bark. "Jenny Palace's evil henchmen won't try anything until morning. And we need to be in top form tomorrow. How long has it been since you've eaten?" he asked the 186 Dalmatians.

"In terms of food, we have nothing to complain about. We got two bowls per day," answered a Dalmatian mother named Morgan.

"Yeah, they wanted our skin to be nice and tight for, you know what…" added the little voice of Top, one of her five young puppies, before shivering and moving closer to his mother.

"What a coward!" Thunder, one of his brothers, exclaimed. He was a tough little guy so covered in spots that he was almost black, making him look like a Labrador with freckles. "Just let them try to come close! I'll bite them in the calves!"

"Well, all the better. With your bellies full, you'll all be in good shape for the ruckus we're going to raise for Jenny Palace and her gang as soon as the sun rises. Don't worry, little Dal, we're all going to escape from this island." Bogart's reassuring voice made the puppy smile and wag his tail.

The other dogs didn't notice, but Barbarella had the most loving look in her eyes while she watched Bogart talk so nicely to the puppy. Even though this was far from the right moment, she couldn't help imagining Boogie as the father of a wonderful litter of Dalmatians that she hoped to have one day.

"How are we supposed to get out of here on our own when we can't escape by sea or by air?" asked Junior, a Dalmatian with eyes as piercingly blue as those of a Husky. "Plus, as I'm sure you noticed when you arrived, the island is full of surveillance cameras. We're on an island. Unless we go round and round, chased by our kidnappers like in an old Tex Avery cartoon until they get tired, there's not much we can do."

"Sometimes you can learn things from the classics. And I didn't say we would get out on our own," Bogart replied mischievously. "As for the video-surveillance system, we're going to use it to our advantage. But for that, we're going to need a computer whiz," he continued, looking at Charlie.

"Did I just hear 'whiz'?" asked Charlie, sticking out his big pink tongue. "Was someone talking about me?"

"During the flight, Barbarella told me that you were capable of infiltrating the systems of the CIA and the FBI. Did she overestimate you?" added Bogart, winking at Barbarella.

"You found your dog, handsome! Put a keyboard under these hacker paws of mine and I can do whatever you want," said the Bearded Collie, flashing the underside of one of his paws and spreading his paw open to move each articulation with incredible agility. "Send me R2D2 from his galactic junkyard and I'll transform his heap of scrap metal from the prehistory of microprocessors into the latest Playstation! But, before that, I wouldn't mind having the leftovers from your bowls. Because I don't know about Barbarella, Bogart and Suntzu, but as far as I'm concerned, since we haven't gotten our teeth into anything since we left Los Angeles, I'm absolutely starving!"

"You're right, my furry friend. Before listening to Bogart's plan, let us eat. Because, as the sage said: 'a hungry belly has no ears.' I could gulp down bowls and bowls of the delicious fried rice that my kind masters Wong prepare for me."

"And I could eat giant pepperoni pizzas that my nerd master, Peter, and I chow down on during our video game nights."

Bogart kept quiet, but he also started thinking about the happy moments he had spent with Eddy wolfing down spaghetti carbonara after their surf sessions in Malibu. As for Barbarella, she remembered watching old films with Marianne, while eating dog biscuits. The

Chihuahua also tried to recall some happy memories with Jenny Palace, but it wasn't an easy task. He saw himself stuffed into ridiculous coats in the chic boutiques of Rodeo Drive, thrown like a football into the pool when the billionaire broke up with one of her recent boyfriends (which happened almost every week) or being called a "four-footed reject," one of the many nicknames she gave him. But he could also see himself sleeping nestled in the arms of the young woman, who held him tenderly like a teddy bear when she forgot that she was the famous Jenny Palace splashed all over the scandal pages of celebrity magazines and became simply "Jenny." Most importantly, she was his mistress.

Bogart told the group that he would share his plan at dawn, when everyone would be rested. Then, the vast garage became more and more silent, only broken by the delicate snuffles from the dogs' noses. The impressive pack of dogs, mainly black and white, seemed to breathe at the same rhythm. Then, after each one of them thought of their masters who were waiting for them somewhere, the dogs surrendered to sleep, one by one. A sleep marked by dreams of returning to their beloved masters whom they missed so much. And, sometimes, the silence was broken by little yaps caused by a nightmare and stretched-out paws in disordered movements that seemed to scratch the ground during the troubled sleep of the dogs.

Bogart was the only one who couldn't sleep. He spent most of his short night looking lovingly at Barbarella, who was nestled against him. Reassured, she had fallen asleep quickly by his side. The warmth and delicate scent of the pretty Dalmatian's fur, her heart-shaped nose, just like his own, and the sweetness of her lovely breath did him a world of good. The little dog, who abandoned herself to him, trusted him completely. He knew that Barbarella didn't doubt for one moment that he would save them all. Like the rest of the pack, she had placed all her hopes in him. But Bogart knew that while his plan was the only one that would give them a chance of escaping from the horrible schemes of a dangerously deranged billionaire, it was far from being infallible.

When the first rays of sunlight entered the garage, the Dalmatian's bright hazelnut eyes shot with flecks of gold were wide open. His millions of sensory endings were on alert, his nose was perked up and his muscles were taut. Bogart was ready for action.

23/ The Dalmatians' garage prison. Jenny Island. The Hawaiian Islands.

The pack was wide awake now, listening attentively to the one whom the 186 kidnapped dogs had named "The Last of the Dalmatians" before his arrival. Bogart, who had climbed onto the mezzanine of the garage, began to explain his escape plan to them.

"Don't you think Mr. Handsome looks a little like Steve McQueen?" Charlie asked Suntzu.

"It's true that our Pongo has real style. A true Ming emperor," responded the Shar Pei. "And, what's more, I know someone who has fallen for his black and white charm," he added, gesturing with his nose towards Barbarella, who was literally drinking up Bogart's every bark.

"Yeah, that's the problem. Hmm, I though Mings were vases," the Bearded Collie added quizzically.

"Friends, in less than an hour, the humans will be getting out of bed," Bogart continued. "We're going to prepare a doggishly hellish morning for them. Gucci, you confirmed that the island is packed with video-surveillance cameras, but that for the moment, the security service is at its minimum until Jenny Palace inaugurates her birthday celebration, right?"

"*Si señor*," answered the Chihuahua, standing at attention. The little dog had found some grease in the garage and had done up his face like a commando. "There are only two guards watching the video screens linked to the island's cameras," he continued in his Mexican accent. "The office is in the nightclub building. This is also the room where all the electronic and computer equipment is centralized, as well as all the means of communication on the island."

"Good," said Bogart. "Gucci, Suntzu and Charlie, report there. While Gucci and Suntzu distract the guards, Charlie will connect all of the video cameras to the Internet. Will you be able to send all the video footage of the island to the Hawaii State Police?"

"Not just to the Hawaiian cops, but to the whole world!" responded the Bearded Collie. "Give me some nice shots to forward and I'll take care of the rest."

"Don't worry about that," continued Bogart, his eyes sparkling mischievously. "I have it all planned out. You should get started now, while I explain my plan to our friends."

"*Hasta la vista, baby*!" called out Charlie, imitating the human voice of the Terminator. "Hey Sun, stop your Chinese exercises and get over here. Pancho Villa and I are waiting for you."

The Shar Pei finished his last kung fu exercises before joining them. Then, the three dogs quickly left the garage thanks to Gucci's remote control, making sure to leave the door open behind them.

"As soon as our three friends accomplish their mission, it will be our turn," Bogart explained. "And now, Dalmatians, listen up and listen good. The dog party will soon begin! We're going to show Jenny Palace and her pathetic henchmen our Dalmatian Nation. The dog show must go on!"

24/ Jenny Mansion. Jenny Island. The Hawaiian Islands.

The blinds were all shut and the enormous room was still plunged in darkness despite the first rays of sunlight that had slowly invaded the rest of the billionaire's island residence. In her triple queen-size heart-shaped canopy waterbed, under one of her endless embroidered satin night masks (this one said "Keep moving, nothing to see here"), Jenny Palace was still sleeping like the baby that she had refused to be for so long. The many sleeping pills that she had swallowed as easily as others might eat M&M's had more than something to do with it.

Used to partying until dawn when she was in Los Angeles, Miami, New York or Europe, she couldn't fall asleep at a normal hour. After one evening on the island that her parents had given her, the jetsetter was officially bored. Because, for Jenny Palace, a night without partying until dawn, surrounded by her nighttime friends, was a night not worth living. Just like an afternoon without ridiculously expensive shopping (this concept being very far from possible for commoners).

As she hated to be alone and gloomy in her house, she forced Alberto V and Tony Pinofarino to keep her company until they finally crashed, despite the Vitamin C powder that she had secretly poured into their coffee. They had ended up falling asleep in front of the TV, which was as big as a movie theater screen.

These two fools weren't interested in anything, she thought to herself, as she left them sleeping in the sofas of her projection room. Yet, she had planned an amazing video line-up for them, meant to captivate them until morning. The evening had begun with excerpts

from celebrity shows all about the daily life of the billionaire, doing her shopping in luxury boutiques on Rodeo Drive or dancing on the tables of a famous beach club in Saint Tropez, France. Then, they got the privilege of seeing endless episodes of a reality TV show called *The Poor Life*. Five seasons (60 episodes) in which her girlfriend Nicolette and she had lived with humble fishermen's families in Florida.

To conclude, she had planned to end the night with videos of all her songs. Unfortunately, the two dolts fell asleep around two in the morning, at the best part of the fifth episode of *The Poor Life*, her favorite one. The episode where Nicolette and she had a fight in bikinis and high heels, hitting each other with bluefins, giant fish from the Florida waters. A great moment in television that became an Internet classic.

In the arms of Morpheus, under her pink satin heart-shaped quilt, she was now having a wonderful dream. Her birthday party had finally arrived. At the top of the steps of the island nightclub, covered in the same red carpet used for the Oscars ceremony, Jenny Palace – in her long dress designed by a famous Italian couturier – welcomed her guests. The flashes of photographers exploded around her, as well as spotlights from TV channels who came via a flight chartered especially for the occasion. Every major name in the music industry, movies and show business was there. Not one Hollywood celebrity would have dared miss "Jenny's black and white birthday party".

This dream of the party that would actually take place in a few days brought a small smile to her lips and comforted her sleep. At the bottom of the red carpet, her new long-awaited toy was waiting for her. Wrapped in an enormous pink ribbon, the Dalmatian-covered Bentloyce was simply magnificent, drawing admiration from all the guests and catching the attention of the TV cameras. The billionaire pictured herself running amidst the flashes to discover her gift. Tony Pinofarino was holding the driver's door wide open so that she could slip inside. But right when she sat down on the deliciously soft seat, covered in fine, delicate black and white skin, the car started making a strange sound that caused the crowd to murmur.

"What's this ruckus?" she asked the tacky designer. "It sounds like a…a…"

"A bark?!" exclaimed Jenny Palace, jumping from her bed, brutally awakened from her dream. She lifted her mask, which she kept on her head to keep her blond hair back. She was sure she hadn't dreamed this. She definitely heard a bark. She mechanically looked for her Chihuahua, groping under the quilt with her hand in case her dog, who had disappeared during the night, had decided to come back while she was sleeping. But she knew Gucci's squeaky little voice too well and was certain that it wasn't him barking under her windows.

Furious to be awoken so harshly and from such a lovely dream, the billionaire jumped out of bed and ran to the window, loudly clacking open the shutters.

At first, Jenny Palace thought it was a nightmare. Leaving the window open, she went back to bed and put her mask back on her eyes to return to her dream as quickly as possible. But the barking started up again, louder this time and accompanied by more barking and then more still. It was indeed a nightmare, but Jenny wasn't dreaming.

Tearing off her sleep mask, she jumped out of bed again and raced to the window. She was furious when she saw what was below. Three floors down, all around the pool, there was a group of about 20 Dalmatians, perhaps more. As soon as they spotted her, they all started barking, creating a horrible din. A little in front of the others, like a pack leader, was Eddy's dog with his blue medal with the initial B. The Dalmatian that they had brought over in the luggage hold of her jet the day before. Her reaction was on par with her anger.

"TONYYYYYYYYYYYYYY!" she screeched, to be heard above the barks of the furious pack of dogs, while one floor down, the window of the projection room opened to reveal the groggy, barely awake faces of Tony Pinofarino and Alberto V, who couldn't believe their eyes or their ears.

"What arrre all these *bellissimo* Dalmatians doing down there?" wondered Alberto, who still wasn't aware of his boss's sinister plans. "I heard that spotted animals are good luck," he told the sketchy designer. "Kind of like ladybugs…"

"I think that these ones will only bring us trouble," responded Tony, before daring to look up towards his client's window.

"Would you mind telling me how these dirty mutts got out of the garage?" she spat, leaning dangerously over the ledge. "I remind you

that they all have to be killed before noon if you want time to skin them all today. My birthday is coming closer and I will not tolerate it if my Dalmatian-skin Bentloyce isn't ready in time."

"But-a, what-a is she talking about?" asked Alberto. "A car covered in dog skin? But-a, it's-a horrrrrible!"

"A few must have somehow gotten out of the garage. Don't worry. I'll call Brice Ohno and Alan right away and we'll deal with these mutts ASAP," he told Jenny Palace, as he dialed a number on his mobile phone. "Get over to the Jenny Mansion pronto, guys. I think we have a slight problem with the Dalmatians," he said quietly. "And don't forget to bring the gear."

"You better, you worthless creep. I want them all to be ready to cover my car for the party. Do you read me?"

"I read you loud and clear, Jenny," answered Tony from the lower floor.

"I hope he's not the only one who heard her," said Bogart to his Dalmatian buddies. "If everything went smoothly for Suntzu, Charlie and Gucci, the two cameras that continuously film the front of the house should have picked up all of the evil plans of our ruthless young billionaire."

25/ *Jenny's*. Jenny Palace's nightclub. Jenny Island.

"Hey Sun, 'it's a wrap!' as Spielberg would say," the Bearded Collie announced joyfully, giving a high-five to the Shar Pei. "And bravo to you too, Pancho Villa. We could never have done it without you."

Now it was time for the Chihuahua with his face camouflaged like a soldier from the special forces to give his new friends a high-five. The high-fiving went on for a while, then, looking at the 20 screens, Charlie spoke up again.

"This image of Jenny Palace demanding the slaughter of the Dalmatians will make headlines all around the world. I didn't just hook up the Hawaiian State Police and the FBI to the video feed; the whole world is watching the events here live and direct. It's just a matter of minutes before the police show up on the island. And now our masters must be relieved to know that we're safe and sound. Hey, speaking of humans…"

"You're a genius, Charlie! You're a dog worthy of your master!" exclaimed Peter Hack, with a big smile on his face, looking out from the screen at his dog. "The websites are talking about nothing but your misfortune! Come back to L.A. quickly with your friends. I can't wait to see you, my loyal sheepdog. I can't wait to hear your bark and not just through a webcam."

Bogart's plan to take over the island's communication networks, located in a large office with a view of the dance floor on the upper floor of the nightclub, had worked to perfection. He had the improvisational skills of the wily canine trio to thank for it.

Behind their window, the two guards in charge of the island's surveillance system had been surprised to see the dance floor light up right before their eyes. The spotlights, disco balls and other fancy lights suddenly started moving. Then, music mysteriously started to play. While the dance floor was slowly flooded with a thick fog, the guards recognized the first notes of *Thriller*, Michael Jackson's famous hit. *"It's close to midnight and something evil's lurking in the dark..."* sang the dead pop star's voice. And, right before their unbelieving eyes, the impossible happened. Emerging from the smoke of the dance floor, three dogs started to dance, doing the same choreography as the zombie dancers in the *Thriller* video.

"Fred, I think I'm hallucinating," said the first guard. "Do you see what I see?"

"Yeah, Joe. I see a sheepdog, a wrinkled dog and a Chihuahua who think they're Michael Jackson!"

Abandoning their office, the two security guards went downstairs to verify what their human minds still refused to admit: dogs were dancing to pop music!

Once they arrived on the dance floor, they had to admit that it was true. The Bearded Collie, Chihuahua and Shar Pei were grooving to a zombie dance!

Hypnotized by this surreal show, but also impressed by the dancing skills of the three dogs, the two men stood there watching, gradually moving their feet to the beat, until the end of the song. Fascinated. *"For no mere mortal can resist the evil of the Thriller!"*

They were about to go to the middle of the dance floor to make sure that these dancing dogs were really alive and not just the result of a mass hallucination, when Michael Jackson's song was followed by an Asian melody. They recognized an old disco hit: *Kung Fu Fighting* by Carl Douglas.

The scene taking place before their eyes was as surrealistic as ever. With his two pals gone (Charlie and Gucci has discreetly moonwalked off the floor), the lone Shar Pei was only lit up by the many glints of light thrown off by the disco ball. With a red bandana tied around his head, the wrinkled dog danced to the old 70s hit while miming kung fu movements. Out of this world!

While the two humans could only hear little barks made by the dancing dog, Suntzu was actually singing the words to one of his

favorite songs while he danced. *"Oh oh oh oh..."* *"Everybody was Kung Fu fighting. Those cats were fast as lightning. They were funky Chinamen from funky Chinatown..."*

The two guards were now on each side of the disco kung fu fighting Shar Pei and they still couldn't believe their eyes. Right when the song said: *"Make sure you have expert timing. Kung Fu fighting, had to be fast as lightning,"* Suntzu leaped up on level with their heads and gave each of them a kick with his back feet.

The men immediately fell to the floor before they knew what had hit them. Carl Douglas was still singing. *"The sudden motion made me skip. Now we're into a brand new trip."* Making the most of the guards' trip to dreamland, the three dog pals took their positions at their command post. It couldn't have been easier: it was puppy's play!

26/ Jenny Mansion. Jenny Palace's residence. Jenny Island. The Hawaiian Islands.

When Tony Pinofarino's two acolytes arrived at the billionaire's house, they were glad that they had put on protective gear. The same gear worn by dog trainers from the canine units of the police or army. Real Michelin men! Completely padded, they still felt barely brave enough to face the horde of Dalmatians grouped around the pool, who seemed to be waiting for them without budging a paw. The dogs had now stopped barking. The Dalmatians simply stared at them in silence, baring their fangs impressively.

"My god! What took you so long! She is off her rocker!" their boss yelled at them as he came down to meet them.

"It takes time to put on these outfits, boss," responded Alan. "And it's not easy to drive the electric car when you're stuffed into one of these things."

"Am *I* wearing such a ridiculous get-up?"

"You should be, boss," said Brice Ohno, pointing to his still throbbing behind. "These awful predators are capable of anything!"

"Are you going to talk all day? Go on and catch those mutts so we can be done with it!" screamed Jenny Palace, still hanging out the window of her fourth-floor bedroom.

Grudgingly obeying the starlet, the three bad guys moved towards the menacing pack. They weren't very confident.

"You got the net?" asked Tony, looking at the Dalmatians grouped across from him on the other side of the pool.

"Affirmative," responded the henchmen at the same time, with quivering voices.

"The way they're huddled together like sheep, those stupid brainless mutts are giving us an excellent opportunity to capture them. This will be a piece of cake," Tony Pinofarino reassured them, already savoring his victory. "We'll slowly get closer to them. You will gradually move in, one from each side, and – at my signal – you'll throw the net on top of them. There are barely 20 or so of these idiotic strays. It shouldn't be too hard. We'll teach them to stop staring at us like porcelain dogs. We'll show them how to respect real men. Right, guys?"

"If you say so, boss," answered Alan, who didn't sound convinced.

"Ok, guys, let's go! Tally ho! Charge!"

Alan and Brice Ohno were right to be on their guard. Rule number one: never underestimate a dog! Rule number two: definitely never underestimate a Dalmatian! Rule number three: especially a big group of them! This was even more accurate when the Dalmatians that the three rogues had made enemies of had something unpleasant in store for them.

"*Cave canem*!"

They should have studied their Latin.

Right when Tony ordered the thugs to throw the net over their prey, like wannabe gladiators, more Dalmatians surged from the garden. A continuous flow of black and white animals. They poured out from every direction for several long seconds. In no time at all, the 20 or so Dalmatians were joined by the rest of their friends. And the three hoodlums found themselves suddenly surrounded by 186 Dalmatians who were determined not to get caught.

"I think the net is a little on the small side, guys," murmured Tony Pinofarino, who suddenly lost his cool. "I say we get out of here right now. You don't know where the jet pilot is, do you? I don't know about you guys, but as far as I'm concerned, I have a sudden urge to go back to Los Angeles. Forget about Jenny Palace's thousands of dollars and her stupid Dalmatian-skin Bentloyce. She can just choose metallic paint, like everyone else."

"We're 100% behind you when it comes to getting out of here, but I'm not sure they'll let us go that easily," commented Alan. Large drops of sweat were rolling down under his ridiculously bright yellow spiked hair.

He was right. The 188 Dalmatians, led by Bogart, were slowly but surely advancing to form a half-circle around the three humans, cutting off any possible escape routes and forcing them to move back towards the pool.

The kidnappers were soon backed up to the pool's edge. They could feel their heels balancing on the edge, when the dog leader, the last Dalmatian that they had brought over the day before, started barking, as if egging on his companions.

"I don't like this barking. Nice dogs! Sit! Nice dogs!" Tony Pinofarino tried. "This was all just a joke! You don't really think we'd be able to hurt mutts - I mean pups - as nice and beautiful as you, do you?"

"That's true," embellished Brice Ohno. "Our car customizing services are usually with reptiles. Serpents, alligators, anacondas, if you see what I mean… More bling-bling, you know?"

"Okay, friends. Enough playing with these evil humans," Bogart snarled to the impressive two-toned pack. "Put the bad guys in the water!"

A "Nooooo!" rang out as the first line of dogs jumped up on their hind legs in front of the three henchmen. Before the humans fell into the pool, Thunder, the puppy almost entirely covered in black spots, had the time to bite Tony Pinofarino's calf. Top, his full-bellied brother, copied him.

"I told you I would bite their calves," Thunder bragged to Top.

"Did you see, Mommy? I bit the bad man too!" Top added proudly, before snuggling, along with his brother, between his mother's long paws.

"That's wonderful, darlings," Morgan told them sweetly. "But don't do it again. Because not all humans are like these evil characters. Don't ever forget that dog will always be man's best friend. And that a Dalmatian must be the kindest and friendliest companion of men."

Dog-paddling in the immense heart-shaped pool, the three worthless men had lost all their pride.

"My calves are throbbing," complained Tony. "Those bloodthirsty monsters bit me down to the bone. They're piranhas!"

"You should have put protective gear on like we did. Plus, all the padding makes us float. It's doubly useful, seeing as we'll be in here a

while," added Brice Ohno, gesturing to the Dalmatians who surrounded the pool, preventing them from getting out of the dirty situation that they had gotten themselves into.

"I hate swimming pools," moaned Alan. "Bleach is really bad for my blond hair."

"Congratulations on your plan," Junior, the Dalmatian with the Husky eyes, thanked Bogart. "When we heard those awful humans saying that they needed one more Dalmatian before starting their evil car customization, we all clung to a sliver of hope. 'The Last of the Dalmatians' would save us. And we were right," he continued. "You were everything we could have hoped for."

"A real movie star hero," cooed Barbarella.

"Thanks friends," responded Boogie, slightly embarrassed, while Barbarella proudly moved closer to her male. "But the game's not over yet," he warned, gesturing with his nose towards the electric car moving almost silently away behind the house with Jenny Palace at the wheel. "Half of you stay here and keep your eyes on these tadpoles in their pond. The other half, follow me. We have a little score to settle with this billionaire who thinks she's Cruella De Vil! Come on, we'll cure her of her unhealthy obsession with Dalmatians," he cried, as he set off in pursuit of the car, followed by a hundred or so Dalmatians who were determined not to let the woman responsible for their recent suffering get away scot-free.

27/ Jenny Island. The Hawaiian Islands.

In the rear-view mirror of her electric car, she saw that the pack of Dalmatians was gaining ground and getting dangerously close. The sight reminded her of hunting parties with hounds that she had attended in Europe. Except this time, *she* was the animal being hunted by the hounds.

Jenny Palace was absolutely enraged. How did the situation get out of control? For her, a girl who had always controlled everything since childhood: the (extreme) generosity of her parents, her image in the international media, her tremendously huge contracts, her photos "stolen" by the paparazzi and even her break-ups with her boyfriends. Just days before her birthday, her party of the century at Jenny Island with its international jet-set guests suddenly seemed compromised. Just like the creation of her Dalmatian-skin Bentloyce.

But, for now, she had to get off the island as quickly as possible. She could always come back later to definitively take care of these horrid mutts, with more henchmen who were more competent than that worthless Pinofarino and his two clumsy oafs with their missing pinkies.

Even if it wasn't for her birthday, she swore that her Bentloyce would be covered in Dalmatian skin one day. Billionaire's honor! That's what she had decided and there was NO WAY it would happen differently. For all of Jenny's life, wanting meant having.

As for her birthday party, it was no big deal. She could just rent a neighboring Hawaiian island at the last minute and bring her guests and journalists there. After all, she thought to herself, money makes everything possible. And with the heaps and heaps of money that she

and her family had, Jenny really could do anything. Except get rid of this determined pack led by the two Dalmatians with the blue and pink B medals on their collars. Jenny started to realize that this would be impossible in her ridiculous electric car that seemed as slow as a turtle.

Then, her phone rang.

"Miss Palace, I started the engines. The jet is ready to take off," announced the pilot of her private jet.

"Give me a couple more minutes. I just have a slight problem to deal with," she responded, starting at the rear-view mirror crammed with a multitude of black and white spots.

Jenny Palace knew that at this rate, the Dalmatians would definitely catch up to her before she reached the aerodrome. Looking at the little road ahead of her, she suddenly had an idea that gave her hope. All she had to do was turn right at the first intersection to arrive at the coconut grove and the garage where all the Dalmatians had escaped from and where her Bentloyce was supposed to be customized.

If she could just get into her powerful car and drive over 65 miles per hour to the tarmac where her Jet was waiting, the Dalmatians wouldn't be able to keep up, although their ancestors were all carriage dogs. Without hesitating, she took the road to the garage, still followed close behind by the furious pack. At her destination, just meters from her four-footed hunters, she went through the open door with her car and ran to the room where her sparkling Bentloyce seemed to be waiting for her.

Even though sprinting in five-inch heels wasn't an easy task, Jenny had just enough time to climb into her sports limo before it was surrounded by Dalmatians. Angry as hell and elevated on their hind legs, some of them leaped impressively around the car, barking ferociously.

"You can scratch the paint all you want. Soon the car will be covered with your fur, you sweet little things," said Jenny, who was feeling bolder now, protected in the cozy car decked out in leather and rare wood. Just when she was about to start the car, the starlet suddenly grimaced. Far from the delicate scent of full-grain leather and walnut burrs that were the trademark of the upscale car, the interior reeked horribly of…

"Do you think she smelled the pee that I left on the seats before leaving the garage?" little Top maliciously asked his brother, at a slight distance from the "adults."

"Well," responded Thunder, with a devilish look in his eye. "One thing is for sure: she's sitting in my poop!"

"Gross! How disgusting!" exclaimed Jenny Palace, raising her butt from the seat to notice the damage done to her mini-skirt. "This is repulsive! You'll pay for this, you four-pawed monsters! And for everything else," she added, her face deformed by anger. Then she revved up the powerful engine of her sports coupé.

Jenny Palace jammed her foot on the pedal in the hopes of knocking down as many Dalmatians as she could who were blocking the garage exit. But, quick as lightning, they jumped out of the car's way to avoid being run over.

"See you soon, mutts!" she yelled, still accelerating as she went out the garage door. "Be good until Auntie Jenny comes back and really gives you something to bark about, you black and white brats! It's not over yeeeeeeeeet!"

Her escape, on the other hand, was over quite quickly. Instead of taking the road that would have led to the landing strip by leaving the coconut grove, the Bentloyce drove straight onto a wooden pontoon that led into the sea and crashed in the lagoon. Luckily, the car landed on a small "motu" (Polynesian island) just big enough to hold the vehicle, which had wrapped itself around the sole coconut tree on the island.

"Yes! Yes! Yes! I knew it was a good idea to mess with the car's steering and brakes," Charlie congratulated himself. He hadn't missed one bit of the scene from behind the computer screen.

"I hate these Dalmatians," fumed the billionaire. "Just like I hate all animals on the planet. Well, actually, not all of them," she corrected herself, as she saw the many shark fins turning slowly around the motu, visibly starving. "I'm a big fan of *Jaws* and *Shark Tale*," she added, while above her she heard the roar of a helicopter's blades.

"Miss Palace, this is the Hawaiian State Police. You are under arrest. Don't move!" yelled an officer's voice.

"I don't see how I can refuse," murmured the billionaire, as she waited for the police officers to come arrest her.

28/ Jenny Island. The Hawaiian Islands.

There was no longer anything private about the billionaire's private island. A number of police heroes were patrolling the banks. In the sky, helicopters with their Hawaiian State Police and FBI logos buzzed overhead, their blades cutting through the air. Other choppers were also flying over Jenny Island, filled with cameramen and photographers in search of exclusive shots to send to their respective magazines.

Jenny Palace's staff, maids, cleaning service and cooks, who had no idea about their boss's monstrous plan, tried to answer the questions of the investigators. The personal assistant of the starlet, who was now Public Enemy No. 1, seemed delighted to talk to the journalists packed around him like groupies around a star. Alberto V's fifteen moments of fame had finally arrived.

On the tarmac, protected by police officers, the group of dogs was waiting for a special plane chartered by the FBI to take them to the L.A. Airport, where their masters, contacted thanks to their electronic chips and tattoos, were expecting them. Bogart, Barbarella, Charlie, Suntzu and Gucci were in the middle of a serious discussion.

"Are you sure you don't want to come with us, Gucci?" asked Bogart. "After all that you did for us, I'm sure that my master would welcome you."

"If you have nothing against Chinese food, you can always move into The Pagoda," added Suntzu.

"That's very kind of you, my friends," answered the Chihuahua in his Mexican accent, "but I've decided to change my life. I will never again be a toy dog for his nice mistress or a bling-bling Chihuahua from Beverly Hills. I've decided to join the feds. My new

pal Karl (he gestured to a German Shepherd dressed in a blue jacket with FBI printed on the back, standing at attention next to his master) invited me to join his unit. They're looking for extra-small recruits like me, who can fit everywhere that big dogs can't. A new life is opening up to me, *amigos*. I will never again be a useless fashion accessory. Gucci no longer exists. Now, you can call me by my new name: Guacamole!"

While they were talking, the dogs saw Jenny Palace, Tony Pinofarino, Alan, Brice Ohno and the pilot go by. Cuffed together and surrounded by police officers, they all moved towards a waiting helicopter.

"You're making a huge mistake, officers. The worst police scandal filmed live since O. J. Simpson. When people find out that the incredibly famous and beautiful Jenny Palace was arrested, you'll have riots in all the wealthy neighborhoods of Los Angeles. All the billionaires of Beverly Hills will rise up!" yelled Jenny Palace. Then, softening her tone, she whispered into the ear of a young police officer in uniform standing near her. "If you just look the other way and let me go, I'll put you in my next video. Okay?"

"Hey, Sergeant," asked Tony Pinofarino to another police officer escorting them.

"What is it?" responded the police officer coldly.

"Do we really have to get in the same helicopter as her?"

"Yes, why?"

"Because she smells awful," the four prisoners said at the same time.

29/ LAX Airport. Los Angeles, California.

When the plane landed on the landing strip of the L.A. Airport, people went crazy. A packed crowd was waiting for the dogs as if they were rock stars arriving for a tour. Like a Britney Spears or Madonna concert. On the tarmac, over 100 black and white LAPD vehicles had their flashing colored lights on. The impressive row of police had come out in full force, their helmets pressed down over their mirror sunglasses. But they could barely hold back the human tidal wave of journalists, animal defense leagues, curious onlookers and numerous dogs, alone or with their masters.

The entire city of Los Angeles seemed to have shown up to be at the event that the worldwide media had been talking about nonstop since the day before: "The release of the Dalmatian hostages." Some cats even showed up to show their support, a moving gesture on the part of the feline community of California.

Several hours earlier, the landing of another special charter also created a buzz, but the passengers were greeted with jeers and insults rather than acclamations. The images showing Jenny Palace, handcuffed and surrounded by two FBI agents as she got off the plane, had already made headlines all over the planet. Jenny Palace, whom the public was used to seeing strutting down the streets of Beverly Hills or on the red carpets of gala parties, with perfect hair and makeup and dressed in the latest fashionable outfit, was unrecognizable. Her clothing seemed pulled right out of a trashcan. Her face was deformed by anger and her hair was a mess, like some crazy woman who had escaped from a madhouse. She trotted along,

trying to escape the journalists on her overly high heels. The fallen starlet billionaire did not cut a fine figure.

Scandal magazines that didn't care about journalism ethics or etiquette quickly showed close-ups of her mini-skirt stained with suspicious marks, accompanying the photo with comments as perfidious as they were questionable. "It seems that Jenny Palace lost control of more than just her nerves" printed the magazine *Beverly Hills People.* "A billionaire with a crap life" commented its competitor *L.A. Trash.* In short, in the United States and all around the world, sensationalist media were having a tremendous time. Because this story was *huge*.

The most media-present billionaire on the planet was going to be accused of kidnapping, cruelty and multiple attempts of violent pet murder. There were 287 plaintiffs, not to mention the District Attorney and the animal rights leagues! This was a far cry from the previous legal misdemeanors of the eccentric young woman for drunk driving or indecent exposure in a public place. Jenny Palace was already being called the "serial dog killer" by the media, thus joining the sad pantheon of the greatest criminals in history.

The scandal was so serious that Jenny Palace's parents called on one of the best legal offices in Los Angeles: Cochran and Cochran. But even the most brilliant speech for the defense would struggle to improve the young heir's image. Even the White House was shocked by the atrocious fate that Jenny Palace had reserved for the kidnapped Dalmatians. "A civilized country cannot accept such barbarous acts against anyone and particularly against man's best friend. No we can't!" announced the President of the United States in a press conference, while he carried Bo, his little Portuguese Water Dog, in his arms.

The director of the famous Bentloyce automotive firm declared that he was horrified and outraged that such a morbid use could be imagined for the star vehicle of his luxury car range. To support the dogs, he promised to donate 5% of profits of each car sold from that day on to animal protection associations and to offer the kidnapped dogs two years of dog food.

On the LAX tarmac, once the four propellers of the plane came to a standstill, the back of the impressive U.S. Navy Hercules C130 aircraft opened, revealing the 190 dogs, obediently sitting next to the

20 or so officers who held ten leashes each. Amidst the black-spotted white coats were some dabs of gray and chocolate: the Bearded Collie and the Shar Pei broke up the two-tone harmony of the Dalmatian pack.

"Fix your hair and adjust your bandana, my bearded friend. The photographers are waiting for us," said Suntzu.

"I hope that they can 'spot' us amongst all these spotted Dalmatians!" Charlie quipped.

"It's like the 4th of July," Bogart said when he saw the packed crowd in front of them.

Confirming his impression, a military fanfare started playing *The Star Spangled Banner*, while the first dogs showed their noses at the door of the cabin: Bogart, Barbarella, Suntzu and Charlie, ahead of the rest. Seated demurely on their hind legs, all of the dogs respectfully placed their right paws over their hearts.

A little farther away on the landing strip, between two German Shepherds standing at attention, a little Chihuahua – who was dressed like them in a blue jacket with the letters FBI printed on it in yellow – proudly saluted the flag with his paw. Guacamole, formerly Gucci, winked discreetly at his friends, who had recognized him.

When the musicians played the last note, the pack and their accompanying officers stepped out onto the tarmac so gracefully that it seemed like a dog show.

The dogs instinctively and immediately identified their respective masters, separated from the rest of the crowd by roadblocks.

"I think that our masters became closer during our absence," Barbarella said to Bogart, showing him Eddy and Marianne locked in an embrace, visibly in love.

"I think that you're going to stay in Los Angeles for a very long time," added Bogart.

"It's not such a bad idea," responded the Dalmatian, nuzzling her favorite male with her nose. "I couldn't bear to leave you and go back to France."

The dogs would have recognized the scent of their masters amongst thousands of other humans. In a matter of seconds, all one could see or hear was the wagging of tails and joyful barking. And soon, the canine cortege that had stepped off the plane so sagely,

became chaotic. The police officers, each holding ten or so dog leashes, couldn't keep them back for long. Breaking away from the officers, the Dalmatians, as well as the Shar Pei and the Bearded Collie, raced to their masters. Not one owner of a stolen Dalmatian was absent.

For the masters whose Dalmatians were kidnapped outside of California, Jenny Palace's parents, on the advice of their lawyers, had made a point of paying their plane tickets for Los Angeles, as well as one night in one of the hotels of the Palace chain. In some cases, entire families with their many children cried for joy as they reunited with the Dalmatian that they thought they would never see again.

The return of the prodigal dog! The licks given to the masters were as numerous as the petting caresses given to the dogs. The reunion between the dogs and their masters, filmed by TV cameras, was so touching that even the most hardened of the L.A. paparazzi were surprised to find tears in their eyes.

30/ West Hollywood Psychiatric Hospital. Beverly Hills. 10 months later.

Two hours per day, all of the patients came together to watch TV at the ultra-select PHOW (Psychiatric Hospital Of West Hollywood), which no one called a madhouse anymore, although since its creation in the 1930s, the establishment had treated or at least housed hundreds of crazy and even dangerous people, all from wealthy families in Los Angeles.

After her show-stopping trial, which monopolized the attention of the media and caused an uproar amongst the public for a whole month, Jenny Palace ended up in this high-surveillance refuge for exceedingly rich mental patients for the last 18 months. Thanks to the brilliant speech for the defense by the very costly legal firm Cochran and Cochran, who brought together a team of no less than 15 lawyers to defend the billionaire, Jenny Palace got off easier than expected.

Pleading the sudden insanity of their client as her birthday drew near, which was not very difficult to prove, the clever lawyers avoided the possibility of state prison. Then, due to the regret that she publicly showed, not just in words, but also in her actions, by transforming her private island into a refuge for abandoned animals, she softened the hearts of the jury and journalists alike.

Jenny Island, renamed Foreverland, was now home to over 1,000 animals pampered by a carefully selected veterinary staff. For tourists in Hawaii, the animal island had become a must-visit attraction. This made it possible to self-finance the charity work of the repentant star, who was still a formidable businesswoman.

Jenny Palace, whose doctors were already announcing her full recovery, was getting ready for her upcoming freedom. While

awaiting the chance to indulge in her former passions as a nightclubber and serial shopaholic, Jenny Palace, like the 50 or so mental patients of PHOW, now had her eyes riveted to the TV screen in the leisure room. Suddenly, an image brought the patient out of her sluggishness – mainly brought on by the various sedatives she was given each day.

On the TV screen, her eyes locked on a movie billboard visible behind a TV presenter standing in front of the red carpet of the Chinese Theater in Los Angeles. Jenny knew this place well, as she had been invited there for many film premieres, including her own. Then, she saw them moving down the red carpet…

After one hour of the *Red Carpet* show, dedicated – in the words of the presenter Angie – to "the movie phenomenon of the year," Jenny Palace was overcome by a terrible desire to scream, to break everything around her and even to tear apart the well-coiffed hair of the other pathetic patients who were watching this stupid program so calmly. It's true that she would have felt much better if she could have gone ballistic on everyone. But, she controlled herself. Just months away from freedom, now was not the time to give in.

Back in her room, Jenny Palace was furiously breaking one of the pencils that she used each day to express her new passion for drawing, when the nurse came to tell her that she had a visitor. The billionaire was surprised, as she wasn't expecting anyone. Her parents had been in to see her that very morning. And just yesterday, her agent had her sign dozens of contracts for films, videos, records and even exclusive interviews in preparation for her release from the hospital.

Jenny Palace asked the nurse who the visitor was. "It's your aunt from England." This was even stranger, considering that no one in the Palace family lived in England.

When the visitor entered the room, Jenny Palace recognized her in an instant, although she had never actually met her. The woman was the same as in her photos. As sophisticated as ever, time seemed to have no hold on her. Wearing a fur coat and long red satin gloves, despite the Californian heat, the mysterious visitor still had her strange hairdo: parted in the middle, with black hair on one side and white on the other.

"Hello 'Auntie,' it's nice to meet... I mean, to see you," said Jenny Palace, while the nurse left them to be alone in the room, one of the many privileges of this hospital.

"Come give me a hug, my daughter in spirit!" answered the improbably old lady, who had grown even more terrifying with the passing years. She embraced her tightly before kissing her on the cheek and leaving a lipstick mark in the same vermillion red as her gloves. "To meet the woman who courageously followed in my footsteps, I would have crossed the Atlantic Ocean several times over," she added, as she examined the padded walls of the room, covered in the starlet's drawings.

"While I was locked up for 18 months, I discovered my talents for drawing," Jenny Palace explained, while the old lady in black and white pored over the sketches one by one.

"Interesting. Very interesting. I love the theme and the colors. Dear child, I think that we have many things in common that we can delve into as soon as you are released. I've decided to move to Los Angeles. I've just rented a little place in Beverly Hills, not far from your home. This way, we can spend a lot of time together. That is, if the company of a wily old lady is not too tiresome for you," added the Englishwoman.

"Oh, on the contrary!" Jenny Palace assured her. "You have always been a role model for me. I'm sure that we can accomplish great things together. The projects are already on these walls. I just needed someone trustworthy to make them happen," she said, showing the lady "her work": creepy drawings of houses, planes, hotels and even a skyscraper, all white with black spots.

EPILOGUE

Chinese Theatre. Hollywood Boulevard. Los Angeles, California.

When they climbed out of the long black limo and into the spotlights and photographers' flashes, the crowd raised a cheer. Since the start of the afternoon, hundreds of fans were pressed against the roadblocks that surrounded the movie theater on Hollywood Boulevard, the famous L.A. street with its sidewalks marked by handprints of movie stars and singers.

Dozens and dozens of hands and paws stretched out feverishly behind the impressive row of security agents in the hopes of catching a glance or getting an autograph, handshake or pawshake from their idols. Because the crowd of admirers included just as many dogs as humans.

"You see?" said Max, buzzing with energy, as he took Eddy and Marianne by the shoulders. "I told you that I would make us stars." He stopped suddenly to take out his mobile phone. "Sorry, Leonardo, I can't be your agent right now. I'm overbooked for two years," he said, not even lying this time.

"What do you think?" the agent asked, obviously satisfied, as he looked up at the poster of the film starring Eddy, Marianne, Bogart, Barbarella and their pals Charlie and Suntzu. The title of the film, written in large letters, announced *The Last of the Dalmatians.*

"You have to ask Boogie. He's the real hero of the film," answered Eddy, petting the Dalmatian whom he held on a leash to cross the red carpet. The dog wagged his tail and looked at his master to show how happy he was. Then, he turned to look at Barbarella, who was at Marianne's feet.

"And what do you think, Barbie?" asked the Dalmatian, before tenderly licking Barbarella's nose.

"Who could ask for more than to live in Los Angeles with the bravest and handsomest Dalmatian and our wonderful little Dalmatian pups," answered Barbarella, while the four little black and white puppies that Max was trying to control cuddled against them to hide from the flashes of all the cameras.

"Max Lose, you are Eddy Fellow's agent. Can you answer some questions for our channel while the film cast poses for photographs?" asked Angie, the presenter of the *Red Carpet* show.

"I'm actually the agent who represents Eddy, Bogart and the main stars of the film. Not to mention 30 or so other Hollywood stars. And don't get me started on all the other unhappy stars – whose names I won't mention for confidentiality reasons – who I can't even take on as clients, as I'm too busy. Just a few minutes ago, I had to refuse poor Leonar…"

"Back to *The Last of the Dalmatians*," Angie interrupted him. "Why this title?"

"At first, Eddie had thought of calling it *The 188 Dalmatians*, but he thought that was kind of has been," he explained.

"Tell us how this film came about?" the presenter continued.

"Well," Max began, "I don't have to remind you of the real and dramatic circumstances that everyone knows by heart and that inspired this story. Let's just say that after everything happened, I urged my friend Eddy, whose writing talents I had always believed in, to tell the whole story in a book. Several months later, thanks to my talents as an agent, this book quickly became a worldwide bestseller and all the major movie firms fought over the film rights. The film production then insisted that Eddy write the screenplay and that the main protagonists of the incident, especially the Dalmatians Bogart and Barbarella, play their own roles. The same applied to their pals, Charlie, the Bearded Collie, and Suntzu, the Shar Pei, who you can see on the red carpet behind me," he said, pointing to the dogs who were strutting their stuff in front of the photographers. "Those two dogs are great actors. They're going to go far in Hollywood," he mentioned. "Only Gucci, the Chihuahua who used to belong to Jenny Palace, was replaced by a dog actor, as the FBI refused to lend him to us for the shoot, claiming that he was on a mission. The ironic thing is

that the young, talented Ripley Scotch, whom I had met at the film shoot of one of Jenny Palace's videos, and whom I now represent, was chosen as the director."

"In the end, the adventure of the Dalmatians and their masters resulted in a lovely fairytale, don't you think?"

"We're in Hollywood! The City of Angels, darling! Even though nothing is ever just black and white, there are still happy endings. It's still possible for a story to end with: 'And they lived happily ever after and had many children and puppies'," concluded Max tenderly, turning to look at his friends.

The camera followed the agent's gaze and stopped on Eddy and then Marianne, whose full tummy under her evening gown showed that she was awaiting a happy event. Surrounded by Bogart, Barbarella and their four white puppies with black spots, the young couple glowed with happiness, as photographers' flashes exploded around them in an atmosphere filled with the sound of cheers and barking from the crowd who came to pay tribute to the last heroes of Los Angeles.

The End

Edmond TRAN
Edmond.tran@hotmail.fr
23, rue des Saints Pères
75006 Paris
FRANCE
Mobile: 011 33 6 21 68 85 17

www.ingramcontent.com/pod-product-compliance
Lightning Source LLC
Chambersburg PA
CBHW022022170526
45157CB00003B/1314